SPOONER'S
MOVING
ANIMALS

SPOONER'S MOVING ANIMALS

or
THE ZOO OF TRANQUILLITY

Paul Spooner

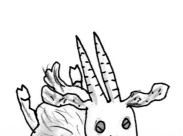
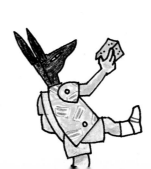

Harry N. Abrams, Inc., Publishers
New York

For Sue, Olly and Tim

EVERYONE SHOULD GO AND SEE CABARET MECHANICAL THEATRE, COVENT GARDEN, LONDON
Making machines is usually a serious business and there are few mechanics whose aim is simply to amuse. Cabaret is a sanctuary for such eccentrics, and visitors can witness dozens of absurd machines cheerfully flouting most of the rules of real engineering. The show is run by Sue and Peter Jackson without whose help and kindness, I for one would never have got started.

I relied heavily on Peter Dormer throughout the writing of this book. His good sense and ideas have saved me from many a pitfall. Jane Smith, Sylvie Bellew and Deirdre Watts introduced yet more clarity into an otherwise hazy affair. I would like to thank Bob Vickers for his clear guidance and good design, Steve West of Brian Gregory Ltd for dedication beyond the call of duty, and Peter Marshall for the excellent photography.

Many other friends have stifled their yawns and taken the trouble to reduce the number of errors of taste, judgment and fact, especially Sue Spooner, Ernie Cross and Trevor Burston.

Stithians, June 1986

Library of Congress Catalog Card Number: 86-70506
ISBN 0-8109-2331-9

Text and illustrations copyright © Paul Spooner 1986
Photographs copyright © Bellew Publishing Company Limited 1986

Published in 1986 by Harry N. Abrams, Incorporated, New York
Reprinted in 1987
Designed and produced by
Bellew Publishing Company Limited
7 Southampton Place, London WC1A 2DR
Printed and bound in Italy

CONTENTS

PART I THE REASONS WHY

PART II THE INSTRUCTIONS

PART III THE WORKS

THE REASONS WHY

THE RISE OF THE SMOOTH AUTOMATON

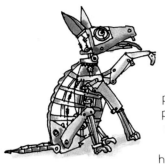

Why should people have such extravagant fantasies about mechanical men? We still cannot make them and yet a belief in the possibility of their existence has persisted since Classical times. In the matters of flying machines and mechanical men it seems that imagination has always leaped ahead of technology.

When Theseus met Talus (the enormous Man of Brass who, regular as clockwork, stamped around the shores of Crete) he automatically assumed that it was some kind of machine. Even though the technology of the time must have been hard pressed to produce a serviceable wheelbarrow, Theseus felt able to take for granted technical abilities that would be the envy of today's engineers. Always a man of action, Theseus was content to wrong-foot the monster and allow it to crash into the sea never to be seen again.

This must have come as bad news to the engineer Hero of Alexandria (c. 200 B.C.) who would have loved to look inside Talus to find out how he worked – and more particularly how he was powered. Hero had experimented with heat, water and air to produce movement and had managed some small effects such as making the doors of model temples open when a fire was

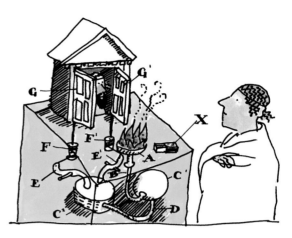

THÉORÈME XXXVII de HÉRON d'ALEXANDRIE

lighted in front of them, causing brass birds to sing and other figures to move, apparently of their own accord (automata).

Ancient accounts of these and other automata might lead one to believe that those who made them possessed miraculous powers. That may be true, but they also had a feel for the art of presentation. Even a modest mechanism can be made to seem marvellous by the addition of a little movement and the subtraction of a little light.

AN EARLY AUTOMATON

The very fact that the things moved without any apparent human agency must also have impressed contemporary observers. Even today when we are surrounded by examples of machines that move without being pushed, there still lingers the feeling that movement equals life.

When I catch sight of something slipping from the towel rail, reason tells me it is only a towel, but the thought has involuntarily occurred to me that it might have been a living thing. I do not think this is the effect of a morbid fear of towels but of an instinct for self-preservation that is tuned to check out any sudden movement for possible threats.

The brilliant automaton-makers of the eighteenth century had no need of effects theatrical or psychological. With them the fantasy of artificial life began to be realized. Much of the mechanical engineering talent of the time was engaged with the problems of accurate time-keeping, and spring-driven clockwork

A TOWEL SLIPS

One idea must have dominated the minds of these automatists: that given enough gears and springs and levers, a machine could be made which was exactly like a person. Nowadays, in Japan much work has been done to produce figures that look, feel and move like human beings. Just as the Swiss automatists tried to produce lifelike movement in their machines by all the means then at their disposal, so people of our own time pursue the same quest.

had reached a high state of efficiency. It is clockwork that powers the automata one can see still working at the Museum of Art and History in Neuchâtel, Switzerland. The museum's pamphlets make much of the fact that *their* organ-player's fingers actually work the keys, whereas an inferior machine's would only follow the keys while the organ played itself.

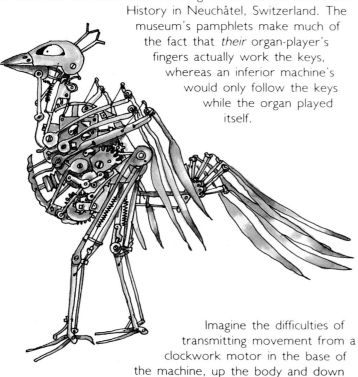

ET VOILA !

I think, perhaps perversely, that the effect of these carefully made things is not one of naturalness. It seems to me that the more nearly the machines resemble people, the more sharply the remaining differences between them and us are brought into focus. It is not natural to subject a real human being to the minute examination the almost-human machine invites.

Imagine the difficulties of transmitting movement from a clockwork motor in the base of the machine, up the body and down the arms (which are themselves moving) to each of the ten fingers and thumbs precisely enough to press the right key, with the right pressure for the right length of time to make music.

ALMOST HUMAN

UP THE BODY ETC.

ROUGH AUTOMATA AND
THE ZOO OF TRANQUILLITY

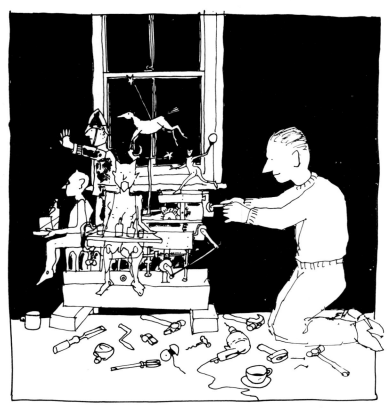

A ROUGH AUTOMATIST AT WORK

The mechanism drives the coffee spoon around. The hand which appears to stir has no motive power. To animate the hand so that it actually did the stirring, one would have to make equivalents for the muscles and tendons of a real arm. This is not the way of the grass verge. You will understand from this that in the Zoo of Tranquillity, not only are the movers shamelessly exchanged for the moved, and causes confused with effects, but also that such inversions are deemed virtues and we can rejoice in the saving of time and material.

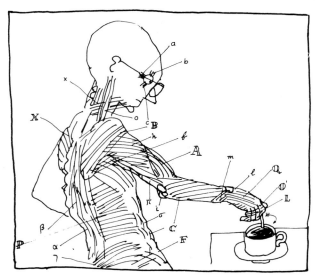

PRINCIPAL MUSCLES EMPLOYED
in Stirring a Cup of Tea.

Typically, a rough automatist avoids the pitfalls of naturalism as he avoids all hard roads, preferring to tread the pliant grass verges. The Zoo of Tranquillity is carpeted with soft turf and is designed to help the rough automatist and his creatures feel at home. Always on the lookout for short cuts and half measures, he likes to take advantage of the gaps in people's perception to create cheap but cheerful effects.

People are prepared to accept certain things at face value – it's only 'common sense'. For almost everyone on the planet the fact that the earth revolves around the sun is interesting but irrelevant. The effect is and always has been of the sun's revolving around the earth. Everyone – excluding astronomers and rocketeers – perceives this to be the case in their everyday dealings with the universe. If people can suspend their disbelief on an astronomical scale, then some small deception in the matter of a mechanical toy should pass without comment. Look at the picture of a jackal swatting a fly as he stirs coffee.

We can enjoy, too, the contrast between rough and smooth automata by comparing real and false Fabergé eggs. Carl Fabergé was a very smooth automatist who made jewelled Easter eggs for European and Russian royalty. Some of his best ones contained little automaton cockerels or elephants that performed when the egg was opened.

The picture of my rough Fabergé egg shows how an amusing effect can be had for very little outlay. As you can see, the cockerel is only a pig in disguise. No need therefore for an expensive cock-a-doodle-doo effect. Instead a pair of serrated wooden wheels produces a grunting sound.

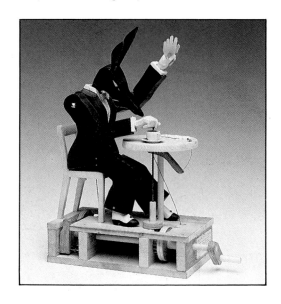

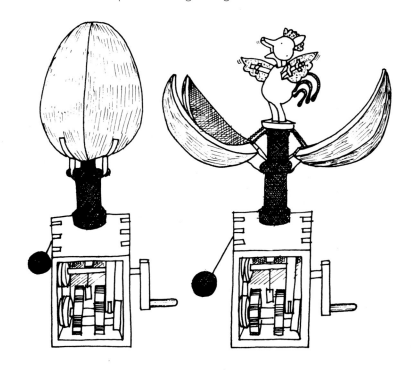

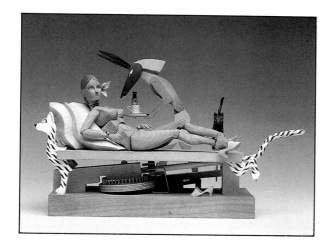

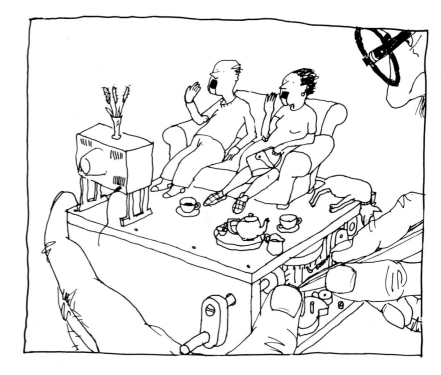

To erect a fragile joke on the substantial foundations of work like Fabergé's is a useful trick. I have also hitched rides on the reputations of famous artists. Manet's painting *Olympia* is the basis of the mechanical object shown here.

The real painting is of a self-possessed woman wearing only a necklace, a slipper, a bangle and an orchid. Lying on a bed of plump cushions, she stares coolly out of the picture to the discomfiture of those who look at her. Her black maid standing behind her holds up a bunch of flowers, designed, perhaps, to flatter her mistress's flesh tones. At the foot of the couch, a black cat can be made out indulging in some cattish stretching and tail-twitching. The painting raises many questions: Is the woman really in control of the situation or is she just the unwitting victim of old-fashioned male exploitation? Why are the flowers wrapped in newspaper? What is the cat doing? Cats have no mystery for me. I know their lives are spent in an unending round of self-gratification so I know just what this one is up to.

By choosing one's subject and materials carefully, great economies of time and resources can be made without sacrificing the joys of creation. This is not to say that there is no place for the expensive sort of machine. There are still skilled people to meet these needs but alongside them another breed of workers can live on their wits. They can focus on the commonplace routines of life for which a cheap machine is a perfect metaphor: The seven machines lurking in the back pages of this book take an unserious view of inadequacy, drudgery and mortality that amounts to a sort of three-dimensional cartoon show whose background and technical workings will be explained later.

Having, I hope, evoked a relaxed and lighthearted mood, I must turn to the ticklish subject of instructions. I am aware that those who follow them are volunteers, and it would be unseemly in this tranquil haven to adopt the hectoring tones with which some practical books address their readers. My wish is to guide you firmly but tactfully to a successful outcome.

There may be those who, though rough automatists at heart, feel unable to take part in the practical activities of the Zoo of Tranquillity, deeming them perhaps to be an unnecessary expense of time and effort. Our director has their interests at heart and will allow them to relax on the grass if they can find someone else to make the models for them.

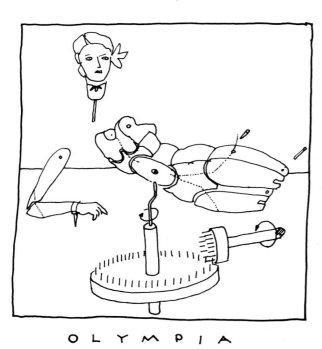

O L Y M P I A

I took Manet's cat and jointed its legs and back so that it could arch and stretch. The woman is made as a wooden puppet with elastic joints holding her body and limbs in order. Elastic threads also connect her to the couch at two points. A bent spike of wire rotates inside her almost-spherical belly section, transmitting a small circular motion to all the connected parts. Her head is nailed to the pillow so that it remains static and staring in contrast to the suggestive gyrations of her body. Little bits of string, wood, brass and cloth represent her outfit. While the cat and the woman disport themselves, Anubis, the jackal-headed Egyptian god, standing in for the maid, brings a cup of soothing instant coffee. A fluttering wire beneath his foot cause a tremor to run up his body and rattle the things on the tray. The key to the interpretation of the piece lies in deciding whether Anubis shivers with excitement or embarrassment.

RELAX ON THE GRASS

9

STRENGTH OF MATERIALS

In his innocence, the backyard engineer relies on his instinctive feel for the strength of materials. Experience and observation tell him all he wants (and usually needs) to know about the design of his structures. If something goes wrong, only he is to blame and, with luck, only he suffers the cuts and abrasions. Next time he will make it stronger.

Disasters are not confined to the backyard. The following description of a human model of the Forth Bridge, Scotland, is well-known and might lead one to think that it was an inherently sound and well-understood structure. 'Two men sitting on chairs extended their arms and supported the same by grasping sticks butting against their chairs. This represented the two double cantilevers. The central beam was represented by a short stick slung from the near hands of the two men, and the anchorages of the cantilevers by ropes extending from the other hands of the men to a couple of piles of bricks. When stresses were brought to bear on this system by a load on the central beam, the men's arms and the anchorage ropes came into tension, and the sticks and chair legs into compression.'

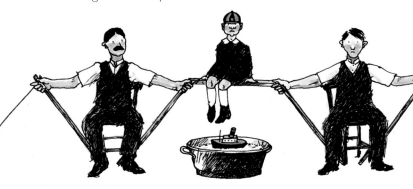

In 1907 when the Quebec Bridge was being built on this principle it fell down. Seventy-five men paid with their lives for a bad guess. Next time they made the bridge stronger. In 1916 it fell down again. The bill was eleven more men. At the third attempt in 1917 the bridge stayed up, a monument to a rather messy empirical method of bridge building. The problem was that at the time not enough data existed to enable the bridge to be built safely and the gaps had to be filled by guesses – bad ones as they turned out to be.

When you put a load on a stiff structure, you cannot tell by looking whether it can bear that load safely. Sometimes the first sign of failure is collapse, which is more or less what happened with the Quebec Bridge. Even a tiny load will cause a movement. Stand on a big bridge and it will be deflected just enough to offer an upthrust equal to your downthrust. (Newton's third law: action and reaction are equal and opposite.) If the bridge were put on top of you, you would be unable to supply an adequate upthrust and failure of your fabric would result.

Paper

In the constructions that follow, the stresses and strains are much more appreciable because the paper is thin enough to be deflected – or bent – by the action of the mechanism. The structures feel as if they are working at the limits of their strength.

This is not to say that paper is a very weak material; on the contrary it is tougher than concrete. You would find a paper-thin flake of concrete quite easy to break in half.

There are difficulties, though, in designing these paper machines. It is not only the stresses imposed by the mechanism itself that can cause damage, but also stresses at the junction between the machine and its driving force, i.e., you. The person turning the handle possesses far more power than is required to drive the mechanism. Imagine a truck engine driving a toothbrush. It would work well, but the excess power could turn itself to destructive effect.

If a strategy for avoiding the wrecking of the machine by itself or its operator is to be found, the mechanical properties of paper have to be understood. Paper will not snap easily – that is to say, it is tough. It also has a high resistance to compression. This may seem odd since a piece of paper is quite easily crushed in the hand. If you place a postcard edge on between the palms of your hands, only a slight effort is needed to crush it, but, with the card still between your palms, try supporting it with your fingers and thumbs to resist the buckling which takes place as you squeeze. The crushing force needed becomes much greater.

Bend your postcard in two and stand it with the fold at right angles to the table. It can support a paperback book. Now fold the two perpendicular edges in to form a triangular tube and tape it up. It can now bear a house brick. The strength of the structure lies in the ability of the corners to prevent the buckling of the sides. It is a mutual support organization.

The plinths on which some of the exhibits in the Zoo of Tranquillity stand remain quite floppy until their bases are glued into place. When that is accomplished you may be surprised by the rigidity of the structure. This information may alert you to the dangers of cutting the roof off your car to make it into a convertible.

The paper used has a slight grain rather like the grain in wood. If you take two narrow strips of it, cut at right angles to one another, you will find that one can be coiled up smoothly, the other will crinkle. Where necessary, the patterns have been placed so that the grain runs the best way.

Not all the pressures on the machines are the result of an awkward interface between paper and flesh. Some high loads are imposed by leverage in the mechanism. Extra material is added to cope with these local stresses and strains. To make shafts and axles from paper is not impossible, but would be an unrewarding chore for all but the most alternativistic constructor. Wooden, rounded cocktail sticks or toothpicks are used instead.

Glue

In all the pieces the adhesive is an important factor. The recommended glue is the white P.V.A. woodworker's type. This stuff forms a clear plastic skin when it sets. Where extra strength is needed, two layers of paper are glued together. In the resulting laminate the plastic adds toughness, stiffness and weight.

THE GOAT

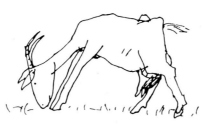

Were you suddenly to turn into a goat, it hardly needs saying that your whole way of life would change. Naturally it would be a shock to see everything from half your customary height. (SAFETY NOTE 1: Assume that if you are a small person you will become a small goat and so on. If a small person became a large goat, his clothes would be dangerously tight.) I predict that your panic would fade as you became aware of unfamiliar but not unpleasant sensations emanating from your stomachs. (SAFETY NOTE 2: Assume that the contents of your alimentary tract have also changed. Were you to retain the old stuff things might go badly.) Goats are used to chewing things over and you would find yourself assessing affairs with unhurried calm. If there were any cause for regretting the metamorphosis, you would console yourself with the thought that you might have had the misfortune to become a sheep. Sheep are chalk to goats' cheese. Although also ruminants, sheep are constructed in a much clumsier fashion with short necks and bulky bodies inspiring in them a mood of perpetual anxiety, which clouds their judgment.

The outward and visible sign of the goat's intelligence is the rhythmic side-to-side action of the jaw. Try stopping your jaw for a moment – your mind will go completely blank. One explanation for the sheep's faulty reasoning powers is that its jaws move only intermittently so that it is unable to transfer a complete idea from its stomach to its mind.

It should be no surprise to learn that our director at the Zoo of Tranquillity is a goat. She stands on her crag surveying all with benevolent detachment. Her jaw movement is carefully reproduced in the cardboard model. A conventional engineer might think of animating the jaw with a crank and connecting rod system such as is driven by the pistons in a car engine. The back and forth movement derived from a crank (called harmonic motion), though beautiful in itself, would result in a windscreen-wiper-like action that is not at all like the goat's gnathic reciprocation.

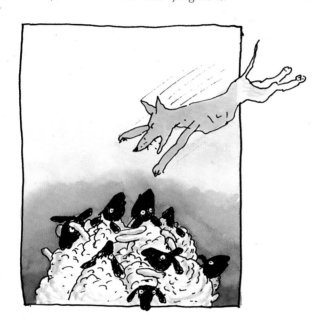

WOOLLY PALPITATORS

When a hungry predator falls upon a flock of sheep, they will huddle together in a palpitating woolly cluster, allowing the predator to take his pick. He would not be so successful with a herd of goats. On being attacked they will scatter in as many directions as there are goats, leaving the attacker empty handed.

HARMONIC MOTION

What is needed is a much more jerky movement with a slight halt or dwell at the end of each chewing stroke. A system of cords and levers, though unfashionable, has been adopted. This method was once quite common. The older type of service bell is a good example. One drawback of the string as a transmitter of motion is that because it has little strength in compression it will only work in the pulling direction. You cannot push much with a piece of string, and so the bell needs a spring to store up enough energy to return it to its starting point. Without a spring the bell would only sound once, which would be irksome if one had inattentive servants.

G O N E

STRING : A SINGLE - ACTING MECHANISM

No springs are used in the goat because a double-acting arrangement of two cords and a lever transmits a pulling force alternately in each direction. The alternating pulls on the cords are supplied by two paddles fixed to the rotating drive shaft. The motion obtained, although hard to describe in technical terms, is quite goat-like.

THE LION

A real lion is an uncomfortable thing. Its uneven temperament and horrible breath ill suit it for the pre-eminence in our society that it is accorded in its own. There is nothing special about lions anyway. Now that wildlife parks are breeding them by the dozen and saturating the market, you cannot give them away.

Even in the Zoo of Tranquillity the King of the Jungle is a fish out of water. It is the aim of the Zoo to be an oasis of calm in a tumultuous and unforgiving world, so, for his own good, we had better cut the lion down to size.

No one likes being laughed at, not even those who can easily cover their embarrassment by socking a few jaws. What is needed is a subtle erosion of that overweening self-confidence which is the hallmark of the natural aristocrat. We must give him the creeping feeling that his slip is showing. Next time he opens his big mouth to roar, let him see how ill-equipped he is for a role in an advanced society. Sooner or later it must dawn on him that his voice is out of tune with others'.

A systematic programme of mockery will have good results only if carried out in small stages. Remember, the idea is not to break his spirit but to change his attitude. Only then will he be receptive to new ideas.

With such a volatile student, retraining must be carried out with tact and circumspection. Try to tailor the course to his interests and never let him get between you and the door.

Technically speaking, the lion model is an arrangement of levers – the simplest form of machine. Archimedes' classification of levers into three orders persists to this day. The long lever, which pushes the word bubble from the lion's mouth, is of the first order type, in that the fulcrum (pivot) is placed between the load and the effort. The load is the word bubble plus the friction that must be overcome to send it out of the mouth. The effort is supplied at the knob as it is rotated through part of a turn.

Levers are often used to convert a small effort through a large distance into a large effort through a small distance or vice versa. They can also, of course, redirect equal efforts and distances to suit some purpose. There is always a trade-off and both sides get a perfectly fair deal. The lion's word lever exchanges a relatively powerful effort through a small distance for a weak force over a large distance in the same time and is therefore travelling at a greater speed. You can feel the effect of this by stepping on the upturned prongs of a rake. Your foot doesn't move far, but, with your weight on it, when the handle end gets going and is brought to a halt by your nose it has covered a greater distance and

consequently is travelling at a greater speed. It is really an easy way to kick yourself in the face. This increased speed, which is a nuisance when an impromptu rake/lever throws itself at you, is helpful in the model lion. The word snaps out quickly and creates a bit of a surprise. The bubble hesitates before being ejected because the lever, being made of an elastic material, bends until it has absorbed enough energy to transmit the effort to the load. Pole vaulters are doing the same thing in a more dramatic way.

The tail lever (of the third order type) is also arranged to move quickly. This is quite usual: most lions feel compelled to raise their tails when they roar. It should only gradually dawn on him that something is amiss. Half close your eyes and you will see a shadow of doubt creep over his face.

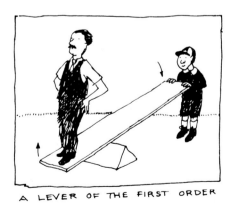

A LEVER OF THE FIRST ORDER

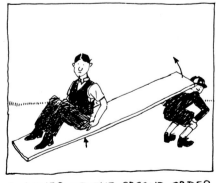

A LEVER OF THE SECOND ORDER

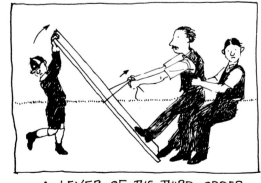

A LEVER OF THE THIRD ORDER

THE WOODPECKER

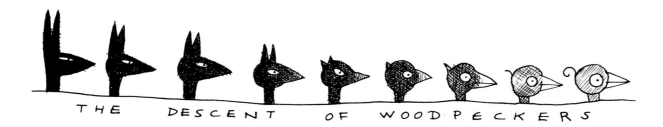

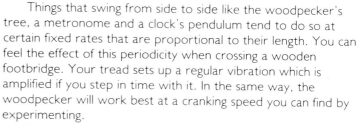

THE DESCENT OF WOODPECKERS

Do you live to work or work to live? The unhappy woodpecker is an example of the latter state. When next you hear his pathetic tap-tapping as he tries to shake his sordid meal of bugs from a rotten tree, consider how he has fallen to this lowly station. His ancestors were artists of fine sensibilities who tapped just as the mood took them and then only on the soundest timbers. They had jet-black faces and long slender ears. Their complex and wonderful tattoos once echoed through groves of stately cedars of Lebanon. Sad to tell, they succumbed to the terrible mechanisms of evolution that grind creation into an ever finer paste of mediocrity. Their ears, made useless by the constant hammering, became smaller with succeeding generations and the species gradually degenerated into the artless cacophonists of modern times.

Things that swing from side to side like the woodpecker's tree, a metronome and a clock's pendulum tend to do so at certain fixed rates that are proportional to their length. You can feel the effect of this periodicity when crossing a wooden footbridge. Your tread sets up a regular vibration which is amplified if you step in time with it. In the same way, the woodpecker will work best at a cranking speed you can find by experimenting.

Do not expect to get a satisfactory pecking action from your model when you hold it in your hand. The tree and the plinth are of roughly equal mass, and so the movement will be shared out between the two. The vibrations in the plinth will be absorbed by the elasticity of your flesh. Hold the model down onto a firm surface such as a table so that the plinth 'borrows' its mass. Then the vibrations are concentrated in the tree and the pecker should rattle well.

VITAMIN DEFICIENCY

The mechanical woodpecker is supplied with two heads that can be interchanged. The mechanism, which is an instance of the confusion of cause and effect referred to earlier, comprises a thin wand of a tree trunk that is rattled from side to side by a cam in the plinth to which it is hinged. As the tree vibrates so the woodpecker's loosely fixed head and body move a little out of time because of inertia – the tendency of things to stay as they are for a while when a force acts on them. (Demonstrate inertia by whipping out the tablecloth from under the tea things.) In effect, when the tree moves to the left, the woodpecker's head moves to the right and vice versa. The sound of the beak's impact is enhanced by the hollow, tapered form of the tree.

HOLDING DOWN

INERTIA

THE WEDDING CAKE

It would be idle to claim that the Zoo of Tranquillity always lives up to its name literally. Many worthy institutions fail to do so. Health authorities deal with the ill not with the healthy, Road Safety Committees spend their time discussing accidents. Their titles reflect the ideal rather than the reality. If we have the occasional row at the Zoo of Tranquillity, it arises out of a genuine desire to reach agreement – just like a peace conference. One such conflict arose over the admission of the Wedding Cake to the Zoo. Two powerful objections were raised. Firstly, that the cake contained no animals – only people – and most of them dead at that. Secondly, that the sudden – and to most people irrelevant – emergence of eighteen skeletons from a wedding cake was an affront to good taste, which would disturb some members of the public.

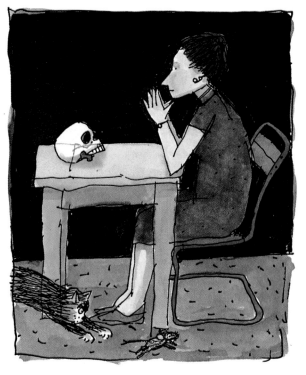

CONTEMPLATING MORTALITY

This is the only pneumatic machine of the seven. The sudden vertical punch under the top cake would be hard to deliver by any other means in a paper construction. If wood and metal were allowed, a spring-loaded mechanism with a trigger would work very well. The opportunity would be missed, though, of adding a little something to the pneumatic system – namely, the inclusion of a small whistle or, better still, a siren.

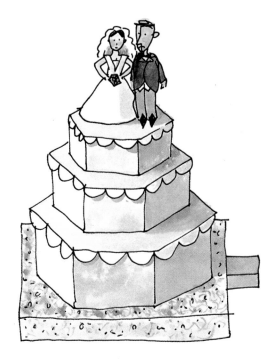

ET IN ARCADIA EGO

High words were exchanged until our saintly director patiently pointed out that in the first place Zoos are for people not animals and that, furthermore, if visitors cannot reflect soberly on their own mortality they shouldn't have come.

The design of the skeletons is such that they will remain in either of two positions – folded or unfolded to hold the lid of the cake either opened or closed. A resistance is felt if you try to move them from one position to the other until a midway point at which the skeletons tend to spring to the second position. This is analogous to the working of an electric light switch in that you must press it a certain distance until the contacts click over.

A sudden impact beneath the lid of the upper cake is needed to lift it and the lids of the middle and lower cakes. This is delivered by a piston which jumps up out of its sleeve when you blow sharply into the air passage at the side of the cake.

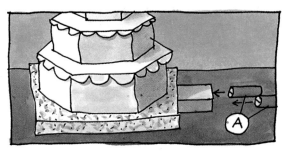

It is well worth the extra expenditure of time and breath.

THE LAWNMOWERS

While not wholly dependent on visitors as a source of income, the Zoo does try to keep up with new trends in public attractions. The success of theme parks has been noted and our own modest version is in operation. It was hard to find a theme that had not already been exploited by rival organizations but in choosing to bring to life the Sunday afternoon activities of Ancient Egyptian undertakers we felt confident of our uniqueness.

The creatures here depicted belong to that breed of jackals which first brought civilization to Ancient Egypt. Impatient with Early Man's clumsy attempts to come to terms with his environment they communicated to the natives their expertise in drainage, plumbing and waste disposal. The Egyptians were enthusiastic students and with great energy set about directing the waters of the Nile into neat canals and arranging the rocks of the desert in nice tidy heaps.

NICE TIDY HEAPS

Chief among these jackals was Anubis, 'Lord of the Mummy Wrappings' and *enfant terrible* of the funeral trade. He raised the art of interment to such an elaborate level of showiness that undertaking became a major industry. The operatives in the business, jackals to a man, constituted a new and affluent middle class for whom leafy suburbs were built.

They maintained their property to a very high standard and were a shining example to us all of how one can live in harmony with Nature.

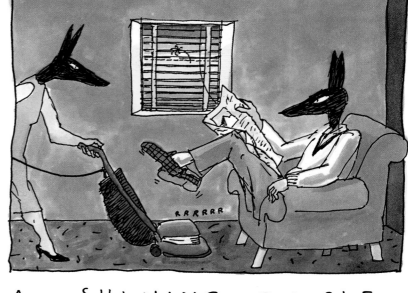

A SHINING EXAMPLE

The inner workings of this piece comprise a movable slide with slots that cause the levers, to which the sponges of the car-polishers are attached, to rock back and forth. The lawnmowing figures are also attached to the moving slide. Their feet dangle through slots in the lawn and are made to imitate a staggering walk by knocking against a corrugated cam in the fixed base of the machine. That is another example of the reversal of cause and effect. The slots that govern the polishing activity are staggered so that the figures work at different times. This is done to evoke in the observer an impression of individual free will at work.

The extra-handy constructor might enjoy motorising this tableau. If you can get a small electric motor geared down to produce an output speed of 60 – 120 r.p.m. it could easily be arranged so that it drove the slide back and forth. The model would last longer driven this way than if it were worked by hand. When parts did wear out they could be replaced with wood or tinplate. This would mean that, in the end, you could have a whole new sturdy machine. Why not make two – or more? You could link them together to create a carpet of moving jackals.

THE HORSE

Not everyone has a way with animals. Some of us find horses unsatisfactory in many respects when compared with newer developments in transport. The lack of brackets for the attachment of accessories that are fitted as standard equipment to other vehicles is a glaring omission. Without brakes, lights or seats it is a scandal that the things are allowed on the roads at all. It would be foolish to expect radical reforms after so many years of toleration, but a modest development programme that addressed just one of the shortcomings of this sacred cow must surely be in order. Why should the horse carry only one person at a time – or two at a pinch?

If we can breed a pig with twice as much bacon on him as the standard type, or a canary that can sing like Frank Sinatra, a multi-seater horse should not be too much to expect. Thanks to a combination of painstaking genetic engineering and some specially designed windlasses, we at the Zoo of Tranquillity are already ahead of the field with our four-seater. The prototype needs

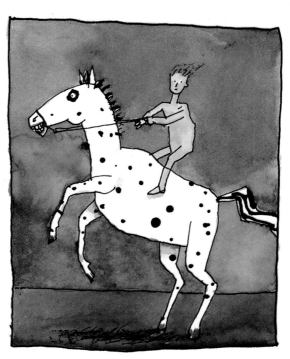

WASTE

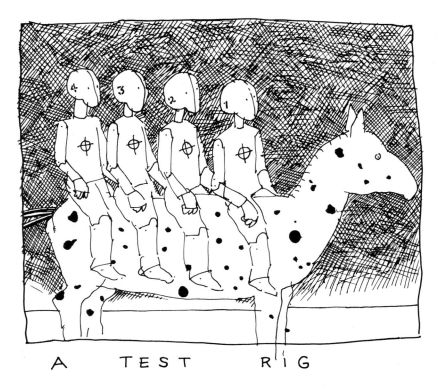

A TEST RIG

small problems, the fuel consumption and environmental impact figures are most encouraging.

It was not until we cantered our first prototype out of the hangar that a chilling thought occurred. What if we had given substance to John's puzzling vision of the 'Four-Man Horse of the Apocalypse'? Nothing very awful has happened since then, but to make certain we are not responsible for setting anything off, we intend in future to concentrate on three- and five-man variants.

The model horse with its four research-assistant-riders is driven by a two-lobed cam in the base. A pushrod rides on the cam and, passing through a sleeve, is joined to the underside of the horse's back. Each turn of the handle produces two vertical bumping movements of the horse's body. The legs are pivoted on shafts passing through the body, but they are also connected by levers to the unmoving inner core of the body, which causes them to swing outwards as the horse rises. The riders are connected both to the moving horse and the fixed core. The effect is meant to simulate the awkward seat of those unaccustomed to horseback.

The swinging legs, pendulum-like, prefer to swing at certain frequencies. As with the woodpecker, you can find the best cranking speed by experimenting.

Where a choice has had to be made, all the machines are built to suit the right-handed operator. If held with the right hand and cranked with the left, the swinging back legs can strike the holding hand. The left-handed may adapt the machine by bringing the handle shaft out of the opposite side of the box to that shown in the instructions.

more work to sort out some minor defects. The coordination between the action of front and rear legs is not perfect, resulting in rather a harsh ride, and we anticipate some difficulties when it comes to mating a pair of these lengthy beasts. In spite of these

THE ANTEATER

What place is there in the real world for this anteater, whose life is conducted at such a strict tempo that he is unwilling to change even to keep on eating? The trouble with anteaters is that things have been too easy for them. For as long as he can remember, this complacent monotreme has had a living handed to him virtually on a plate. All he had to do was hang around outside the anthill and wait until dinner trooped out in a long column right in the path of his sticky tongue.

It is a nice irony that it only needs a small change to turn always-right into always-wrong. The ant must have seized his chance while out of sight in the anthill to take a smart couple of extra paces, leaving the anteater out of step. Perhaps he hopes that sooner or later everything will be back as it was. Only in a cardboard zoo could such a perverse stick-in-the-mud be tolerated. In the outside world, the ineluctable consequence of a failure to adapt is extinction. It looks as if the anteater will be

extinct pretty soon – which will leave the ants in charge. They are a little too smart and business-like to live in harmony with the rest of us. It might be just as well to give the anteater an occasional nudge.

The mechanism that animates the anteater tableau makes it possible to ensure that the relationship in time between the path of the ant and the anteater's tongue-thrust remains constant. The movement of one shaft governs both actions. This shaft runs vertically between the upper and lower surfaces of the box on which the show takes place. To drive it directly would involve having a handle underneath the machine, which would be awkward. Therefore, another shaft fixed at right angles to the first is geared with it so that the machine can be worked by a handle emerging from the front of the box. The gearing is of an interesting type. The driving wheel is made from a disc onto which is coiled a narrow, tapered piece of card forming a spiral on the surface of the disc. As the driving wheel rotates, the tapered edge wedges against the teeth of a star-shaped driven wheel, displacing one tooth at each complete turn of the driving wheel. As there are twelve teeth in the driven wheel, the handle must be turned twelve times for each cycle of the action. This gearing-down of the movement allows time for the observer to appreciate the pathos of the scene.

(The spiral gear is tricky to make, although tests using clumsy constructors have shown that it will still work even if made quite badly. In case you make a real mess of it, patterns for two extra ones are supplied at the end of the book.)

THE INELUCTABLE CONSEQUENCE

THE INSTRUCTIONS

TOOLS AND APPLIANCES

The ideal tool for cutting out is a *scalpel or craft knife with replaceable blades*. They are sold by art and design shops. Get a packet of at least five narrow, pointed blades because you will have to change them as soon as they begin to dull. Always cut slowly and just deeply enough to cut clean through in one pass.

A *steel ruler* is used to guide straight cuts and to score lines. Work over a *cutting board* of thick card. A pair of *sharp scissors* is used to fringe the edges of some parts by close snipping. If you have nippers, they would also be useful.

People with very fine fingers may manage without *tweezers*, but they are helpful. The long, pointed watchmaker's type is best but any sort is better than none.

The machines are designed to be fixed together with *white P.V.A.* or other brand of acrylic woodworking *glue*, which dries transparent. Be sure to get the type made for woodworking as it's the consistency that's important. The drying time depends on the thickness of the application. To join two surfaces, put a little glue onto one and smear it over with a toothpick (or the tip of a finger if you wipe it clean afterwards). It will dry in a matter of seconds. When joining an edge to a surface, use a toothpick to trail a bead of glue along the contacting edge. Glue will squeeze out as the joint is closed and take a few minutes to set, forming a valuable strengthening web of material. Use *clothes pegs*, *bulldog clips*, *rubber bands* and *masking tape* (the sort you can peel off easily) to hold joints while they dry or as a temporary fixing while you test the mechanisms.

While most of the parts can be folded and shaped with the fingers, smooth conical and cylindrical parts are best made around suitably sized formers improvised from pencils, pens, small bottles, etc. Flat seams should be pressed down with a *ruler* or, in a long narrow structure such as a tree trunk, a *knitting needle or chopstick*.

Extra items needed comprise *strong thread* (with *a needle*), *a pin, 3 wire paper clips, sticky tape* and a *small piece of white tissue paper*.

MATERIALS

Round section, wooden cocktail sticks or toothpicks or skewers or medical swabs with a point at each end serve as shafts and stiffeners. These are called *sticks* from now on. The right type measures 3¼'' (80mm) long and about 3/32'' (2mm) in diameter. Size and quality vary between brands and even within one pack so be sure to choose the soundest and straightest. In some cases it is important to use the longest stick you can find so that enough length protrudes for the fitting of a handle. Cut the stick to length

by rolling it between the cutting board and the scalpel. When a stick must be cut after it has been fitted do so carefully with scissors or clippers. Measure the right lengths of sticks against the boxes ⊂═══════⊃ shown in the instructions.

USING THE PATTERNS

Before doing any cutting, score all the creases. The smooth back of the scalpel blade is good for this. Press down enough to make a polished groove in the card without breaking the surface. Score lines are of two types: *hill folds* and *valley folds*. (*See diagram.*) Hill folds are marked with dashes, valley folds are marked with dashes and dots.

When all the score lines have been attended to, make all the small cuts to produce *tight holes* and *loose holes*. (*See diagram.*) A tight hole is formed by cutting along the little cross lines and pushing the pointed end of a stick through from underneath to raise four little lips on the upper surface. These will hold glue when the stick is fixed in place. To *prepoke* is to form the tight hole before making a part to facilitate later assembly. A loose hole is one through which a stick can pass easily and serves as a bearing for a moving shaft.

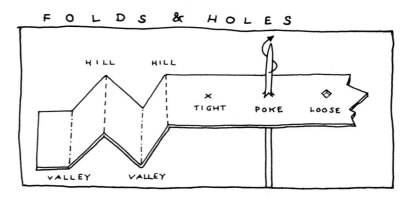

FOLDS & HOLES

HILL HILL

× TIGHT POKE ◇ LOOSE

VALLEY VALLEY

Only when all the details have been scored or cut should you remove each part from the sheet by cutting around the continuous black *cutting lines*. This procedure is to avoid your having to work with a scalpel on small pieces that would be difficult to hold safely.

All the parts are referred to in the text by numbers that appear on the parts themselves except where a part is too small to bear a legible number.

To get an understanding of each machine before you make it, look at the appropriate photographs and drawings as well as the instructions themselves.

The final pattern sheet repeats some of the parts. These can be used in the event of accident to the originals or to gain experience before you tackle the real thing.

Because four of the machines have the same type of handle, to avoid repetition the picture below shows how they are made.

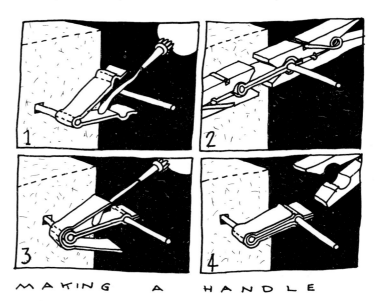

MAKING A HANDLE

G O A T
I N S T R U C T I O N S

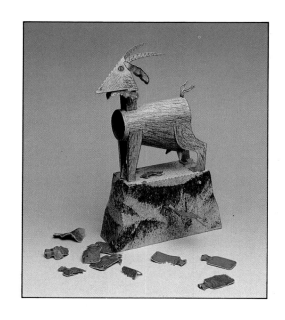

A. Form the body (1) into a smooth cone and glue the seam. Fit the 'back door' (2) and glue into place, making sure that the tail is at the top, i.e. the side opposite the seam. Snip the tail into fine bristles. Fold and glue the neck (3) and fit it to the body. Then make the base of the head (4) and fit it into the top of the neck (3).

Prepoke the hole in the jaw (5) and pass a stick this long: ▭ (50mm) through the hole. Glue the stick firmly into position.

Pierce the two small holes in the rocking bar (6) with a needle. Fold the rocking bar and, taking a needle and an arm's length of strong thread, follow the steps shown in Fig. A.

Now pass the jaw stick down through the neck, and as it passes through the body, slip the rocking bar (6) onto it. Then push the jaw stick through the hole at the bottom of the goat. Check your assembly against Fig. A. Glue the rocking bar at right angles to the jaw. Test the mechanism by pulling alternately on the threads at the back of the goat. The jaw should work from side to side.

from the back door and lead it cleanly towards and through the square hole in the foot. Repeat for the left leg with guide tube (9).

Fold the front legs (10) and then glue them to the blue patches on the front sides of the goat's body.

Fig. B

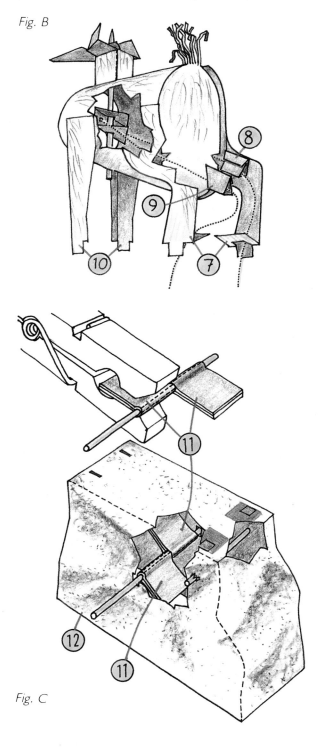

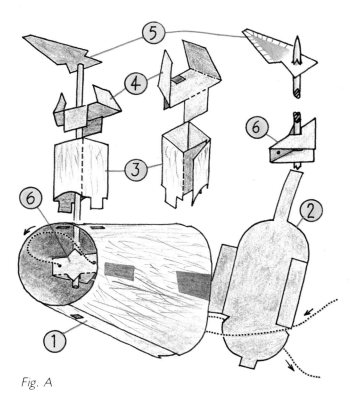

Fig. A

B. Fold the rear legs (7) and glue the top of the legs to the blue patches on the goat's body. Fold and glue the guide 'tubes' (8) and (9) (they are triangular in section – *see Fig. B*). Thread guide tube (8) onto the right thread and then glue the guide tube to the inside of the upper right leg. The aim is to take the thread

Fig. C

C. Take a stick this long: ▭━━━━━━━━━▭ (60mm) and glue the paddles (11) to it as shown in Fig. C. This assembly forms the *drive shaft*. The stick protrudes a short distance at one end of the paddles and a long distance at the other end. Check the position of the paddles against Fig. C.

Prepoke the holes, fold and glue together 'the crag' (12). Then fit the drive shaft into the crag – the short end should poke out of the side with the seam.

Pass a stick this long: ▭━━━━━━━▭ (40mm) through the tight holes in the crag, and glue into position. This is the *guide bar*.

D. Lower the goat onto the crag, passing the threads through the large square holes and behind the guide bar. Glue the rear foot pads to the rear blue foot patches, making certain you do not get glue on the threads. Glue in the front legs. Check that the threads are loose and that they still move the jaw.

Prick a pin through the two dots at the front of the foot of the crag. Pass the threads through the two pinholes and adjust the lengths so that the paddles of the drive shaft activate the jaw. When the action is right, glue the threads at the pinholes.

Glue the two washers (13) onto the drive shaft, one on each side of the crag. Make and fit the handle (14) and (15). Fold, fit and glue the base (16) onto the bottom of the crag.

Fig. D

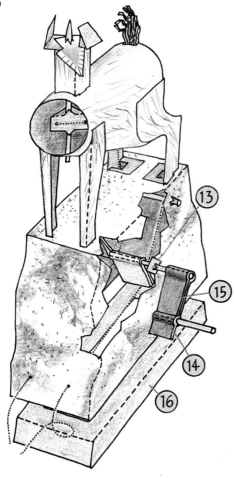

13
15
14
16

Fig. E

17
17

E. Roll the teats (17) around the point of a pencil, and glue them into cones. When they have set, snip each across the wide end with a pair of scissors and glue them to the goat's underbelly between the back legs.

F. The Goat can eat either hotwater bottles (18) or grass. If you choose the hotwater bottles, then fold them in two and glue around a short piece of stick, which will form the stopper. Cut up the bottles and glue them all over the crag, also gluing a piece onto the goat's jaw.

If you choose grass, cut the green corner of this page into narrow slivers and glue a little onto the jaw. Jab some holes in the crag with your scalpel and insert a few tufts of grass.

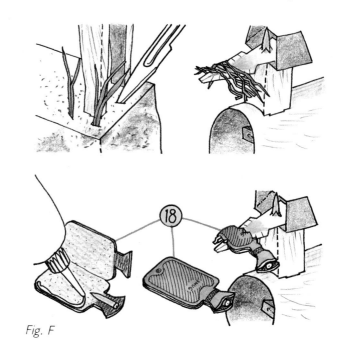

18

Fig. F

G. Glue the horns (19) to the head (20) (*see Fig. G*). Then glue the head to the tabs on the head base, making sure that the jaw and whatever the goat is eating is not fouling the head.

Crumple each ear (21) into a tight ball, then uncrumple and glue onto the head at a suitable angle.

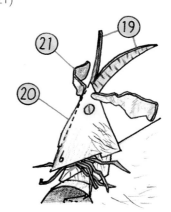

21
19
20

Fig. G

LION
INSTRUCTIONS

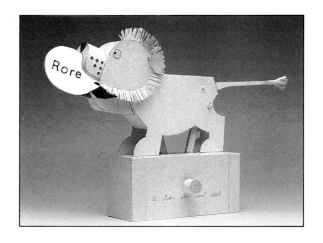

A. Fold and glue the body (1), paying particular attention to the hill and valley folds of the strengthener between the front legs (*see Fig. A.*).

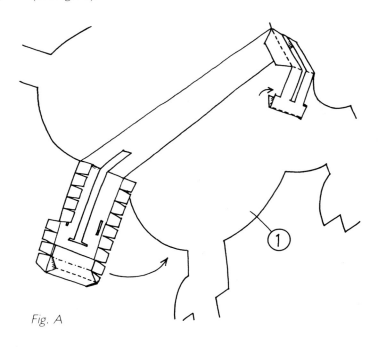

Fig. A

B. Prepoke the holes and fold (2). Glue a stick this long:

(77mm) to the inside. Prepoke and fold (3) around the notched end of (2) and glue them together. Take (4), fold and glue the looped end. Link (4) to (3) with a stick this long: (10mm). Glue the stick to the prepoked holes. You have just made the *linkage* (*see Fig. B.*).

Fig. B

C. Take a stick this long: (70mm), which will be the *drive shaft*, and glue the end of the strip (5) at one end. Let it set. Now wind the strip tightly around the stick, gluing as you go, to make a solid, tight cylinder. Add strip (6) in the same way to make the cylinder bigger (*see Fig. C.*). You now have a drive shaft with a substantial knob.

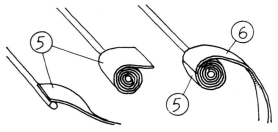

Fig. C

D. Fold and glue the plinth (7) into a box. Take the drive shaft by the knob, pass it through the front loose hole of the box (the side with the writing) and thread on the washer (8). Now thread on the linkage, making sure that it is the right way around (*see Fig. D.*). Thread on the other washer (8) and pass the stick through the back loose hole. Arrange the three skewered parts so that the linkage is held in the middle of the box. Glue the washers and the linkage to the shaft so that when you twist the knob all the parts move together. Use plenty of glue and allow plenty of drying time because there is a lot of strain on this joint.

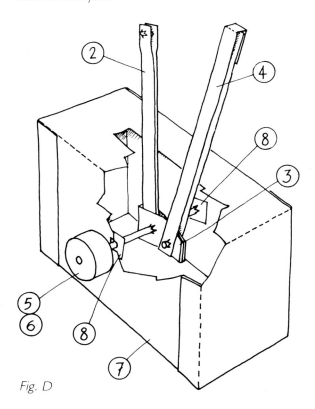

Fig. D

E.	Snip the tail (9) along the orange part and fold and roll (see Fig. E.). Make the brush 'fuzzy' by bending the bristles out a bit.

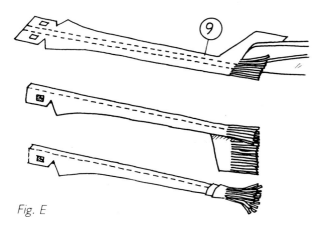

Fig. E

F.	Fit the word bubble (10) between the forks of (2) with a stick this long: ▭ (10mm) and glue the stick into position. The word bubble should move up and down easily.

 Lower the lion into position, threading the word bubble through the neck slot of the Lion's body (see Fig. F.). The lever/pushrod (4) should be inside the body casing. Slot the lion's feet into the slots in the plinth (7).

 Fit the tail into the rear slot in the lever/pushrod (4) and attach with a stick this long: ▭ (20mm) through the prepoked holes in the body (1). Glue.

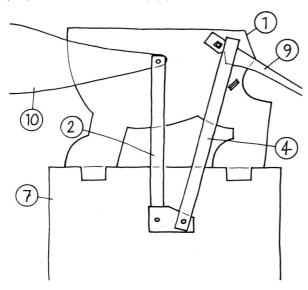

Fig. F

G.	Fold and glue the lower jaw (11), following Fig. G. Fit the jaw into the three slots at the front of the body and glue. Fold and glue the neck (12) and fit it to the body over the white patch.

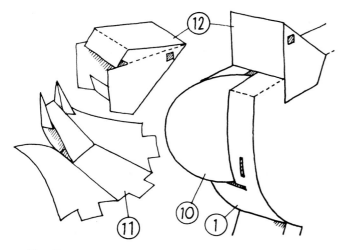

Fig. G

H.	To make the head (13), begin by snipping the mane. Then prepoke the holes, fold and glue. Next, ease and mould the snout (14) into shape, gluing carefully where the edges meet. Connect the snout to the front of the head using the three tabs and their corresponding slots (see Fig. H.). Glue all around. Attach the ears (15) through their corresponding slots – the ear tabs must be glued flat to the inside of the head. Then attach the head to the neck with a stick this long: ▭ (32mm) (see Figs. G., H. and I.). Make sure that the head swings freely.

 Only when you are certain that the lever assembly is firmly glued to the drive shaft should you fold and glue the plinth base (16), which fits tightly into the bottom of the plinth box. It is not shown in the drawing.

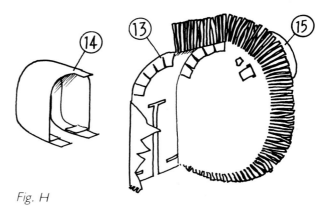

Fig. H

I.	Finally, glue on the eyes (17), the nose (18) and then cut up the dark patch (19) into tiny squares and arrange them either side of the snout (see Fig. I.).

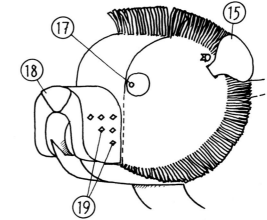

Fig. I

WOODPECKER
INSTRUCTIONS

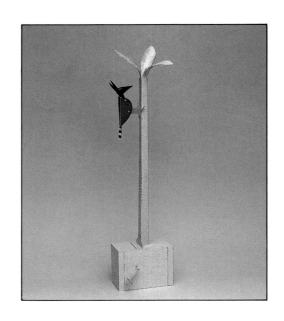

A. Score and cut out all the parts except the five-sided cam, which is left as part of the rectangle (1) to be removed from the middle of part (12) (*see Fig. A.*). Fold the rectangle (1) in half, glue and leave it to dry under a flat weight.

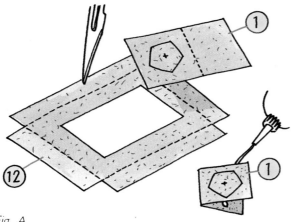

Fig. A

B. Fold and glue the tree trunk (2). And then, to make the cam-follower box, fold parts (3), (4) and (5). Glue (3) and (4) at either end of (5). Your structure should look like Fig. B. Now take the strengthener (6) and glue it into the channel inside (5).

Glue the cam-follower box to the tree trunk, matching the tabs to the square blue guidelines at the base of the tree trunk.

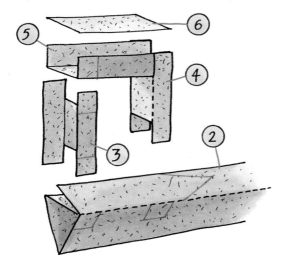

Fig. B

C. Cut out the cam from the glued rectangle (1) and then make the cam shaft from the cam (1), the two reinforcing flanges (7) and (8) and a stick this long:

(65mm). Follow Fig. C. You should have only a small length of stick protruding from one end, leaving enough at the other end to fix a handle to. Glue the cam (1), and the flanges (7) and (8) to the stick.

Fig. C

D. Make the stiffening (9) by folding the creases, paying particular attention to the hill and valley folds. Enclose the strengthening stick as shown in Fig. D. and glue it. Then trim the stick to the exact length of the cardboard sleeve. This strengthening rib is glued under the roof of the plinth (10) to provide rigidity to the structure.

Now glue the strengtheners (11) to the loose holes on the inside walls of the plinth.

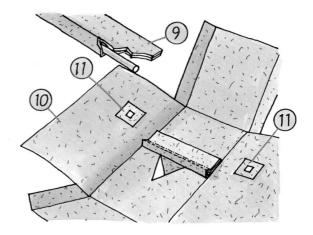

Fig. D

E. Insert the tree (2) into the triangular hole in the plinth (10) from below until the triangular tab of the plinth is in line with the triangular blue marker on the trunk. Glue, making sure the tree is perpendicular to the surface of the plinth.

Assemble the plinth box (10) and incorporate the cam shaft by inserting the protruding bits of stick through the loose holes (*see Fig. E.*). Now fold the plinth base (12) and insert it into the bottom of the plinth. Fold and glue on the hinge reinforcer (13) at the point where the tree trunk descends into the box plinth. Fit the handle (14) and (15).

When all the glue is dry, test by turning the handle. The cam should rotate freely but there may be some resistance at first until the cam has run in. Be sure not to wrench the handle. Hold the box down on a firm surface, then turn the handle. The tree should vibrate.

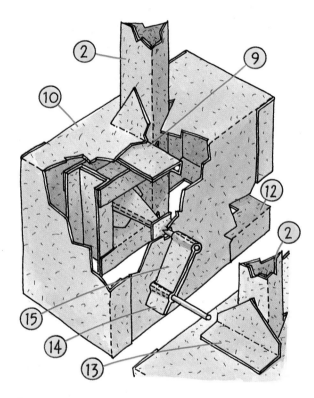

Fig. E

F. Fold and glue the woodpecker's legs (16) and glue the tabs into the slots in the tree (2) (*see Fig. F.*).

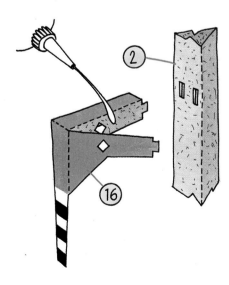

Fig. F

G. Prepoke the holes in the woodpecker's body (17) and glue in the bulkhead (18) (*see Fig. G.*). Fold down the top of the body and glue the 'wings' to the bulkhead and neck slot. Attach the body (17) to the legs (16) by passing a stick this long: ▭ (13mm) through the loose holes in the body and the legs. Make sure the body rocks easily.

Fold and glue on the woodpecker's feet (19).

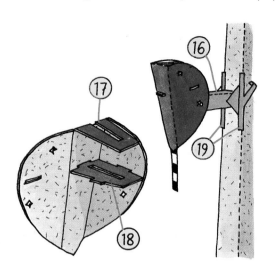

Fig. G

H. Glue the parts of the woodpecker's head (*see Fig. H.*). You have a choice – either a bird's head (20) or a jackal's head (21). If you decide to use the bird's head do not forget the crest.

Fix the head to the body with a stick this long: ▭ (15mm). The head should rock to and fro with ease. Do not glue if you wish to interchange heads.

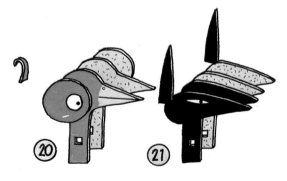

Fig. H

I. Snip the foliage (22) into exotic fronds (*see Fig. I.*). Glue the fronds into the top of the tree, giving each one a twist to simulate a palm tree effect. If you snip too far there are spare patterns on the last page.

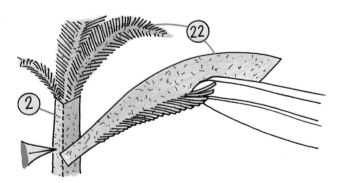

Fig. I

WEDDING CAKE INSTRUCTIONS

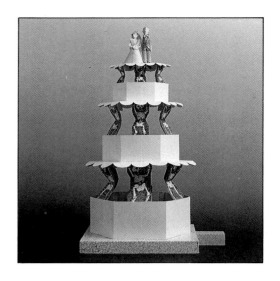

A. Take part (1) and fold the creases, noting hill folds and valley folds. Bring together the triangular tabs at the end of each 'leg' so that they form a hexagon in the centre (*see Fig. A.*). Glue them down in position. Glue the flat base of (1) to the purple hexagon on the smallest lid (2).

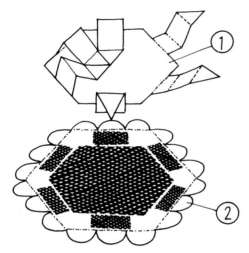

Fig. A

B. Crease the six smallest skeletons (3). Glue the head tab of each skeleton onto one of the purple patches on the lid of the smallest cake (2) (*see Fig. B.*).

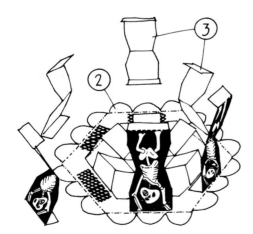

Fig. B

C. Fold the sides of the smallest cake (4). When folded, the cake should be white on the outside and grey on the inside. Then glue the tab to form a hexagonal 'tube'. Glue the foot tabs of the skeletons to the purple patches on the inside of the cake (*see Fig. C.*). Fold the scalloped edges down.

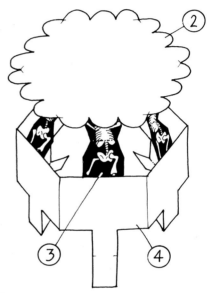

Fig. C

D. Now assemble the medium-sized cake (5), (6) and (7) and the larger cake (8), (9), (10) in the same way, except that there is no part corresponding to part (1). (*See Fig. D.*) On the medium-sized and smallest cakes there are six long tabs. Fold these tabs inwards and glue them back on themselves.

 Fit the base of the large cake (11). The square hole in the base must line up with the square hole in the lid. Glue on the base. The tabs in the bottom of the medium-sized cake can now be fitted into the slots in the lid of the largest cake. Again, ensure that the square holes are lined up. Separate the layers a little, apply some glue, and then push home. Similarly, fit the top cake to the middle one.

 Fold and glue the four corner tabs to make up the square base (12). Then fit the cake into the base, making sure that the square holes line up.

E. Carefully fold and glue the piston (13), the sleeve (14), and the air passage (15) (*see Fig. E.*). The piston should slip smoothly through the sleeve. Pass half an arm's length of thread through the bottom of the air passage (15) (*see Fig. E.*) and through the sleeve (14), then glue the sleeve and air passage together, making sure the end of the sleeve is fitted between the sides of the air passage. Fix the end of the thread that comes out of the top of the sleeve to the inside of the piston with a piece of tape about this long: ▭▭▭▭▭▭ (35mm). Fit the piston into the sleeve and pull the thread back through the bottom of the

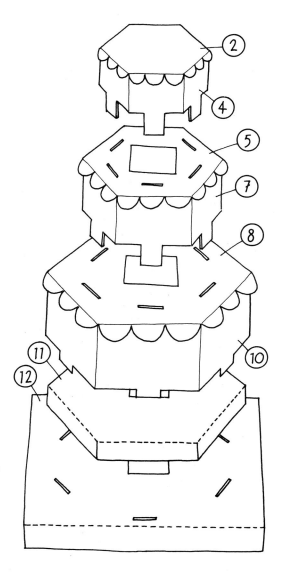

Fig. D

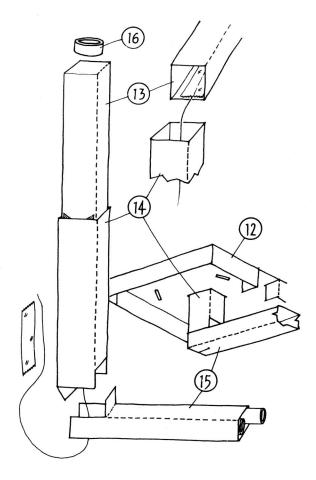

Fig. E

air passage until the points of the red arrows on the piston are level with the top of the sleeve. Tape the other end of the thread to the outside wall of the sleeve and cut off any extra thread. The thread prevents the piston from shooting out of the top of the sleeve when the mechanism works.

Roll the strip (16) into a ring about this size

(12mm dia.) and glue it centrally to the top surface of the piston. Roll up the two strips (17) and glue them side by side inside the mouth of the air passage. Now insert the assembled piston and sleeve up the central square hole in the cake; the air passage fits into the base as shown in Fig. E. Before gluing the piston and sleeve and the air passage into place, test the action by blowing sharply through the air passage: the three layers of the cake should then separate. The puff must be short and sharp; a continuous puff will not work.

F. To assemble the bride and the groom, first form the groom's coat (18) by moulding along the valley fold lines. *Note* that the coat should be darker outside than inside. Glue the tab to close the coat. Fold back the lapels (use tweezers). Form the trousers (19) by rolling the two wings towards the centre; then insert the body into the coat from below and glue into place, leaving about this much:
▭▭ (8mm) neck between the collar and the triangular head tab. Take the shirt (20) and insert it into the coat from below. (*See Fig. F.*) Make the feet (21). Snip a V shape out of the front of each of the trouser bottoms. Glue the feet into place; if they look too long, trim them. Take the man's head (22), bend it into shape, and glue the top together at the parting. Glue the head onto the tab at the top of the neck. Glue on his arms (23).

To make the bride, curve the skirt (24) into a cone and glue it. Fold the bodice (25) to make a double Y shape, and crease the front of the bodice. Put the head (26) through the neck hole in the bodice and glue the front and back of the bodice to the body. Bring the arms out in front of the bodice. Indent the skirt (24) where the rim of the pattern is straight. This will allow the groom to stand closer. Then insert the bride's torso into the top of the skirt. The indent of the skirt should be under the bride's left arm. Bring her arms forward to rest on her stomach. Glue the bouquet (27) in front of the bride's hands. Using part (28) as a template, cut out a veil in white tissue paper and glue it to the front of the bride's head. Fold it back over her head and gather it at the sides.

Arrange the bride and groom on the summit of the cake. Glue in place. Make sure they are well fixed before blasting off.

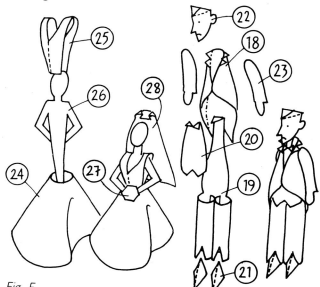

Fig. F

LAWNMOWERS
INSTRUCTIONS

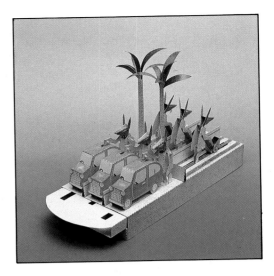

A. Prepoke and fold the three brackets (1). Glue the brackets (1) exactly over the slots in the ground (2). Glue on the three bracket supports (3).

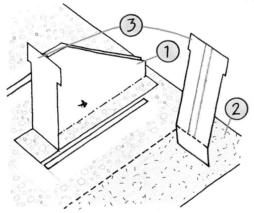

Fig. A

B. Fold the corrugated cam (4). It should be green on top. Put glue on the two flat tabs and on the three lines of contact. Attach the cam (4) to the base (5) using the blue lines as a guide. Leave to dry under a flat weight (e.g. a book).

Temporarily fold the ground (2) and the slider (7) into shape. Then flatten them out again. Fold the three lugs (6). Glue the lugs into the three pairs of slots in the small green rectangles in the slider (7). Fit the ground (2) over the slider (7). The lugs (6) fit into the three pairs of long grooves in the ground. They should slide easily.

Prepoke, fold and glue the three lawnmowers (8). Bend up the fronts of the grass boxes and glue to the sides. The lawnmowers fit over the lugs and are glued to them. Be sure not to get glue on the ground or the mowers will not slide. Insert a stick this long: ▭ (15mm) through each pair of loose holes in the lawnmowers. Prepoke the six wheels (9) and glue one onto each side of the lawnmower shafts. The wheels should turn freely as the slider is moved.

Fold and glue the base (5). Then refold and glue the slider (7) and the ground (2). Fit the ground and slider over the base. Glue lightly. Check the action.

C. Prepoke the three bodies (10) and then make them up by folding and gluing at the neck. Fasten the legs (11) and (12) with a stick this long: ▭ (12mm). The crutch tab (x) should lie above the stick. Do the legs dangle freely? If not, check that the crutch tab is separating them cleanly.

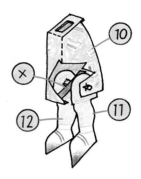

Fig. C

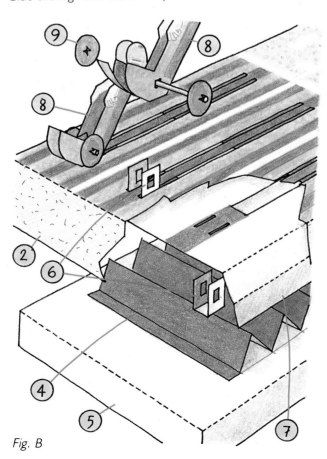

Fig. B

D. Fit the bodies between the arms of their lawnmowers one at a time and adjust them so that the legs, dangling through the double slots, are just nudged by the cam (4) as the figures slide. Be sure you have it right before gluing the arms to the bodies. This stage is a difficult one. If you get into trouble, careful trimming of the foot tabs is possible – or, if you mess it up, there are spare parts for a new lawnmower at the back of the book.

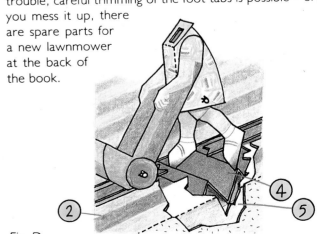

Fig. D

E. Take the two strips (13) and coil them into cylinders – these are used as small strengthening pillars and are inserted into the slider as shown in Fig. E. Glue them clear of the slots.

Make the three cam followers (14) by folding them in half, gluing and leaving them to dry flat under a weight. Then place the cam followers (14) into the brackets (1) and attach each with a stick this long: ▭ (10mm). Put a paper clip on each for weight as shown in Fig. E. You should now test this assembly by moving the slider. The cam followers should oscillate freely. If they are sticky, check that the curved parts of the followers are smoothly cut.

Check that the slots in the back windows are cut before folding, bending and gluing the three cars (15). Stick on the grilles (16). Bend in the bumpers/fenders. Fit the cars over the cam followers. The tabs on the bracket supports (3) fit into the back window slots. The top of the cam followers should poke out through the roofs of the cars. Test the mechanism by gently pushing the slider back and forth. If all works well, put a spot of glue at the junctions between the wheels and the ground.

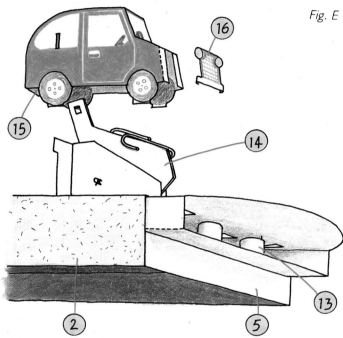

Fig. E

F. Now assemble the three car sponging figures. For each figure take parts (17) through to (22). Attach the legs (17) to the bodies (18) using sticks this long: ▭ (12mm). Attach the heads (19) to the bodies with sticks this long: ▭ (18mm). Attach the sponging arms (20) to the shoulder sticks as shown in Fig. F. Do the same with the free arms (21). Finally, glue the ears (22) to the heads but at this stage do not glue anything else.

Fig. F

Now snip off the corners of the tops of the cam followers that are poking through the car roofs. (*See Fig. F.*) Attach the sponge arms to the cam followers with a stick this long: ▭ (6mm). Arrange the heads. Glue the feet to the white locating patches on the ground.

G. Fold and glue the fence strips (23) through (27). Your fences should form isosceles triangles in cross section. Then assemble and glue the fences on a flat surface as shown in Fig. G. Arrange the exposed tabs as in the drawing. Leave the glued fences to dry under a flat weight.

Assemble the three heads (28) for the mowing figures and glue on the ears (29). Then glue the heads into the shoulder sockets. (These heads look exactly like those in Fig. F.)

Fig. G

H. Gently curl the leaves of the two palm trees (30) around a pencil to achieve a palm leaf effect. Glue the trunks into triangular 'tubes'. Then curl the extra leaves and glue them into the tops of the trees. Finally, glue the trees into position on the ground and against the fence. The bases of the trees are shaped to fit snugly against the fence.

Fig. H

H O R S E
I N S T R U C T I O N S

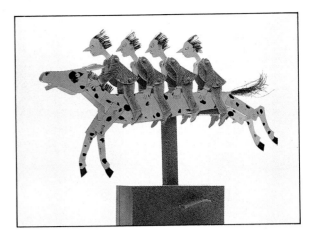

A. Glue rectangles (1) and (2) together. Leave them to dry under a weight.

 To make the cam shaft, cut out the elliptical cam from (1) and (2) and pass a stick this long:

(65mm) through the tight hole in the middle. Position the two strengthening flanges (3) and (4) around the stick, one on each side of the cam. The stick should project only about this: ☐ (10mm) far beyond one flange, leaving the opposite end long for the handle. Glue on the flanges.

Fig. A

B. Make the sleeve (5). It is important to make this sleeve carefully – it should be symmetrical and level at both ends.

 Turn up the triangular tabs in the plinth box (6) and thrust the sleeve (5) through from beneath. Glue the triangular tabs to the sleeve and the rectangular tabs to the box. Glue the box together. Fit the cam shaft into the box by inserting the long end of the shaft into one of the two loose holes. (The long shaft can project from either hole as the base is symmetrical.) Bend the side of the box slightly to get the short end into the other hole. Glue the handle (7) and (8) to the projecting shaft.

 Put the base (9) into the box (6).

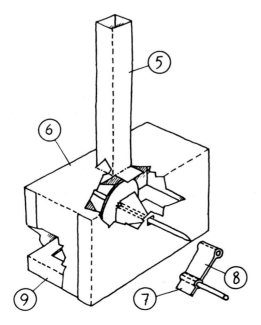

Fig. B

C. Prepoke, fold and glue the crosspiece (10). When it is dry, glue it onto the sleeve (5), making sure that the end of the crosspiece (10) with the slot in it is facing to the right, and that the slot in the end of (10) is as in Fig. C.

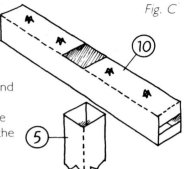

Fig. C

D. To make the pushrod (11), fold and glue it into a straight, closed box. Prick a pin through the printed dot (x) at one end of the pushrod. Take the body (12) and prick a hole in the printed dot (y). Glue the push-rod (11) firmly and squarely to the underside of the horse's body (12) with a pin through both pinholes as a temporary guide.

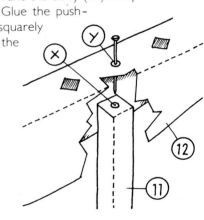

Fig. D

E. Fold the long creases of the body (12) and pass two sticks this long:
(65mm) through the leg holes at either end. Wrap the two flag pieces (13) around a spare stick to shape them. Glue one flag to one leg shaft and the second flag to the other leg shaft as shown in Fig. E. Glue the 'back door' flap of the horse's body into place.

 Fold and glue the neck (14) and connect it to the body using the three tabs. Snip the mane (15) and glue it along the centre line of the top of the neck.

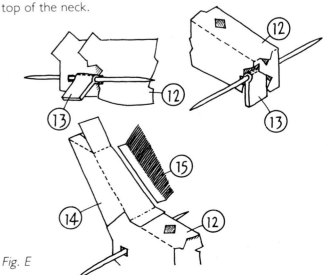

Fig. E

F. Prepoke all the holes in the front upper legs (16) and the rear upper legs (17). Fold along the creases. Now fit the front lower legs (18) to the front uppers, and the back lower legs (19) to the back uppers using sticks this long: ▭ (8mm). The legs should all move easily at their joints. Now attach the legs to the body but do not glue.

Connect the horse to the mechanism. Do this by inserting the pushrod (11) into the sleeve (5). The rear legs are activated by the rear flag (13) – inside the body on the rear leg shaft. Therefore this flag must fit into the slot at the end of the crosspiece (10). Look at the red arrow.

Getting the best galloping action is a matter of experiment. Starting with the flags roughly horizontal and the legs dangling vertically, make adjustments until a good action results. Make sure there is a gap this wide: ▭ (5mm) between the body and the legs before gluing the legs to the sticks. Snip off the excess stick when the glue is set.

Fig. F

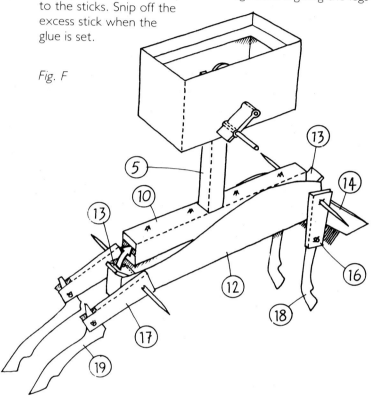

G. For each of the four riders, prepoke the tight holes in the legs (20). Fold and glue the legs. Insert a stick this long:

▭

(45mm) through the tight holes between the rider's legs. Only a small length of stick should protrude through the top flange. Glue the stick into position.

Prepoke the tight holes in the jacket (21). Ease the curved creases into shape and then fold and glue the neck and shirt front into place. Join the legs (20) to the jacket (21) with a stick this long:

▭ (25mm). Prepoke the tight hole in the head (22). Snip the hair and make it wild and wayward. Join the heads onto the shoulders with a stick this long:

▭

(30mm). The stick should pass through the shoulders and the tight hole in the head. Prepoke the arms (23) and give them a gentle curve outwards at the elbows to prevent their rubbing against the body. Then glue one arm at each end of the shoulder stick, but leave the head unglued for now.

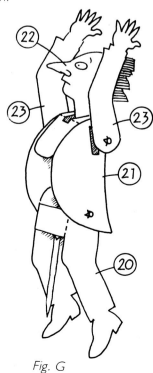

Fig. G

H. Starting at the front of the horse, thrust the sticks that are between the riders' legs into the prepoked holes that appear through the four large holes in the horse's back. These sticks should penetrate the crosspiece (10). A small amount of each stick should be visible underneath the crosspiece.

Turn the handle until the horse is resting at its lowest position. Make sure that the riders' shoulder sticks are resting at the bottom of the shoulder slots (x). Glue the hands of the first rider to the horse's neck. The hands of the other riders are glued to the horse's body. Check their positioning against Fig. H. before gluing. Test the action of each rider before adding the next. Adjust the heads and glue them to the shoulder sticks. Use a pointed stick to get the glue into the joint.

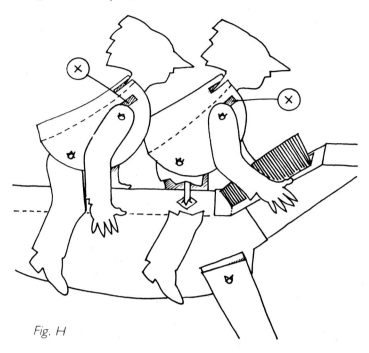

Fig. H

I. Fold and glue the horse's head (24). Fold and glue in the ears (25). Glue the horse's head to the top of its neck.

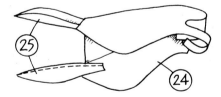

Fig. I

J. Snip with scissors along the dark part of the tail (26). Roll it up, glue it and insert the white end into the triangular hole in the back door.

Fig. J

A N T E A T E R
I N S T R U C T I O N S

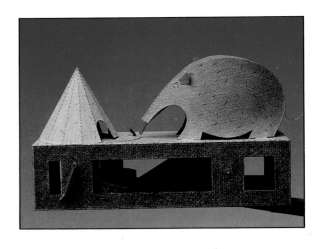

A. Score and cut out all the outlines and holes except the star wheel (1), whose outer rectangle will be folded and glued first. *Note*: it will be easier to make the spiral gear if the base disc (3) is left on the sheet until the slope (2) is glued on.

Fold the star wheel rectangle (1) in half, then glue it and leave it to dry under a flat weight (*see Fig. A.*).

Fig. A

B. Make sure the central tight hole in the disc (3) is cut. Wind the slope (2) around a cylindrical pencil to make a smooth spiral. When you have got the spiral to a shape conforming to the blue printed lines on the base disc (3), place the spiral onto the base disc by slotting and gluing the tab into the slit (*see Fig. B.*). Let it dry, then add a bead of glue to the bottom edge of the spiral and stick it down. When that is dry, cut the surplus card away from the base disc (3).

Fig. B

C. Insert a stick this long:

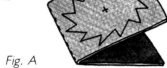

(80mm) into the finished spiral gear. You should have this length: ⬜▭ (13mm) of shaft poking out through the base disc (3). Glue the stick in place, making sure the shaft is set perpendicular to the gear. Glue the flange (4) to the back of the spiral gear (*see Fig. C.*). Thread a washer (5) onto the long end of the shaft but do not glue it yet.

Fig. C

D. Make the cam by forming the cam wall (6) onto the circular blue guidelines on disc (7). Make the triangular spacer 'tube' (8) and glue it to the triangular blue guideline on the disc (7). (*See Fig. D.*) Run a stick this long:

(65mm) through the tight hole in the disc (7). Leave this amount: ⬜▭ (8mm) protruding from below the disc.

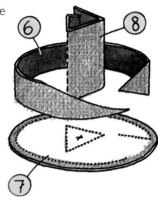

Fig. D

E. Cut out the star wheel and thread it onto the shaft until it meets the spacer tube (8). (*See Fig. E.*) Twirl the assembly between finger and thumb – if, viewed from the side, the edge of the star wheel wobbles, you need to adjust the position of the star wheel on the spacer tube. When you have it running true, glue up the joint between the spacer tube and the star wheel. Make sure the shaft is glued well where it fits in the assembly. It must not slip.

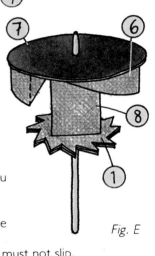

Fig. E

F. Fold the tongue lever (9) in half and glue flat. When this has set hard bend the long tab so that the angle of the tab is about 120 degrees. Pass a stick this long:

(80mm) through the tight hole so it protrudes equally from either side of the lever (9). Fold the supports (10) over the stick, one on each side of the lever and glue (*see Fig. F.*). Make sure the shaft is perpendicular to the lever.

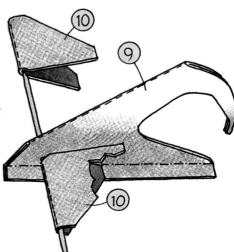

Fig. F

G. Assemble the box (11) and the two ends (12). Glue them together. Add the roof stiffener (13) and glue it down. Then fit and glue down the three wall stiffeners (14) into their slots underneath the roof of the box. The last wall stiffener (15) incorporates a loose hole for the end of the drive shaft. Make sure it is the right way up (see Fig. G.). Now fold the box bottom (16) and check that it fits the box. The tabs in the four wall stiffeners should match up with the corresponding slots in the box bottom (16). Take the box bottom (16) out again.

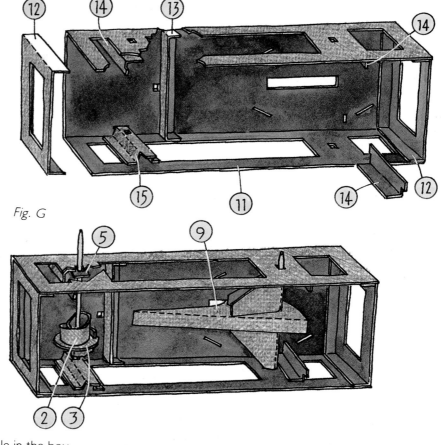

Fig. G

H. Insert the spiral gear (2) and (3) and the tongue lever (9) into their appropriate loose holes in the box (see Fig. H.). Slide the washer (5) along the drive shaft and close to the wall to minimise end play. Glue it to the stick.

Fig. H

I. Place the cam shaft assembly into its loose hole in the box bottom (16), making sure that the cam is resting on the surface of the box bottom (see Fig. I.). Carefully lower the box (11) onto the box bottom (16). Insert the bottom tabs of the wall stiffeners into their corresponding slots in the box bottom. Do not glue the bottom in until you have tested the mechanism by turning the protruding end of the drive shaft *clockwise*. The spiral gear should drive the star wheel and cam. The cam should lift up the tongue lever and let it drop. If it does not work, you may have made the spiral gear badly. At the back of the book there are spare parts to make a new drive shaft. When all is well, glue the bottom to the box and then fit the handle (17 and 18). Glue the washers (19) one on either side of the box over the protruding ends of the tongue shaft.

Push the turntable (20) onto the protruding end of the cam shaft so that it rests on the yellow speckled surface of the box. Glue around the tight hole so that the cam shaft and turntable move as one.

To make the anteater (21), bend the tabs down and form the bulk of the beast by pinching the creases at the snout end and then gluing the tabs to the body a few at a time. When the glue has dried, put the beast into position by fitting the foot tabs into their corresponding slots. Make sure the anteater's tongue action lever (9) is not impeded. If the tongue moves freely, glue the anteater into position. Add the ears (22) and the tail (23).

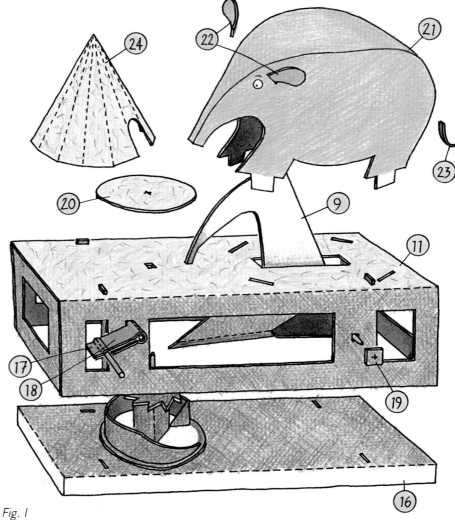

Fig. I

J. The anthill (24) should be folded into a cone and glued up. Place the anthill as shown in Fig. J. with the edges of the hill nearly touching the front and side of the box. Make sure the turntable can still turn freely. If all is well, fix the anthill into position. by running a bead of glue around the long edge of its base. Do not put glue on the edge of the hill that covers the turntable.

Now fix the timing. The point is that the anteater always misses catching the ant, and the timing procedure is carried out to make sure this is what happens: Turn the handle until the tongue has just dropped down onto the turntable. Make a pencil mark on the turntable some small distance beyond this mark – give it a few goes before finally gluing the ant (25) into place. The ant should be positioned just ahead of the mark on the turntable. Before gluing, make sure the ant passes through the doorways of its home without hitting them. *Never let anyone turn the handle anti-clockwise.*

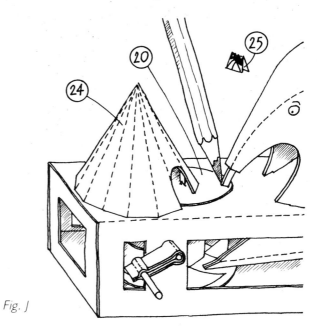

Fig. J

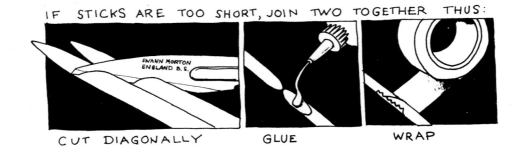

IF STICKS ARE TOO SHORT, JOIN TWO TOGETHER THUS:

CUT DIAGONALLY GLUE WRAP

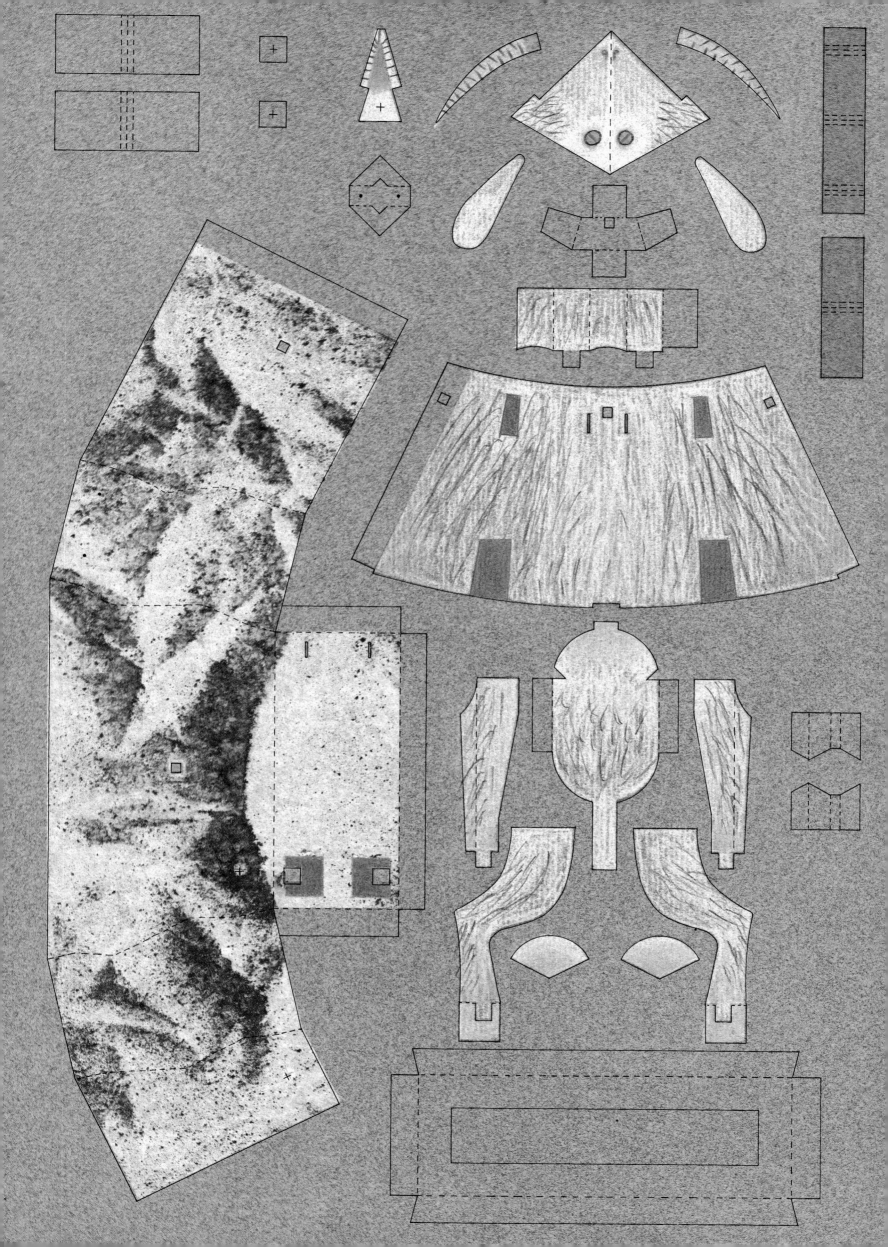

19

19

13

11

5

20

13

14

11

21

21

6

4

3

15

1

10

10

2

9

12

8

7

7

17

17

16

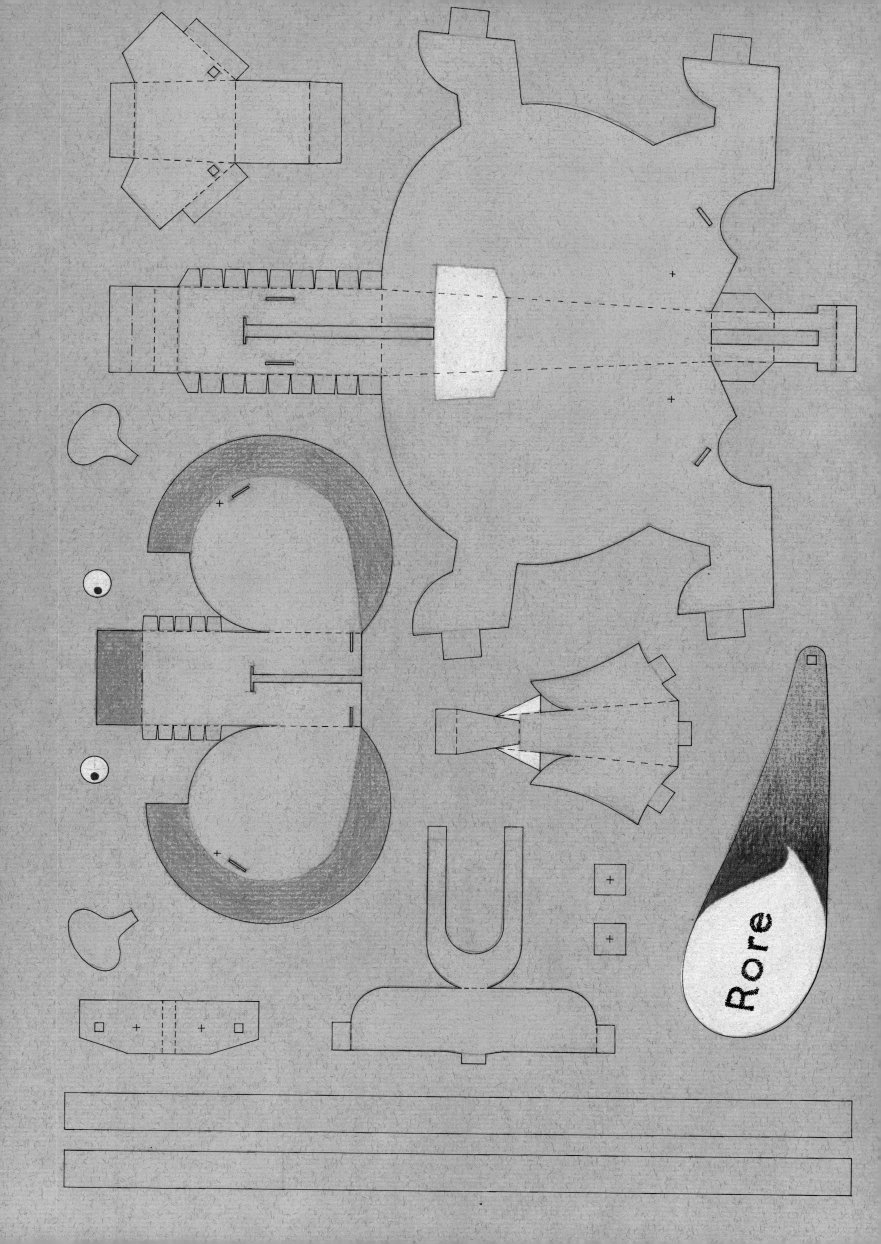

Rore

12

1

15

17

10

13

11

17

8

15

8

14

3

5

6

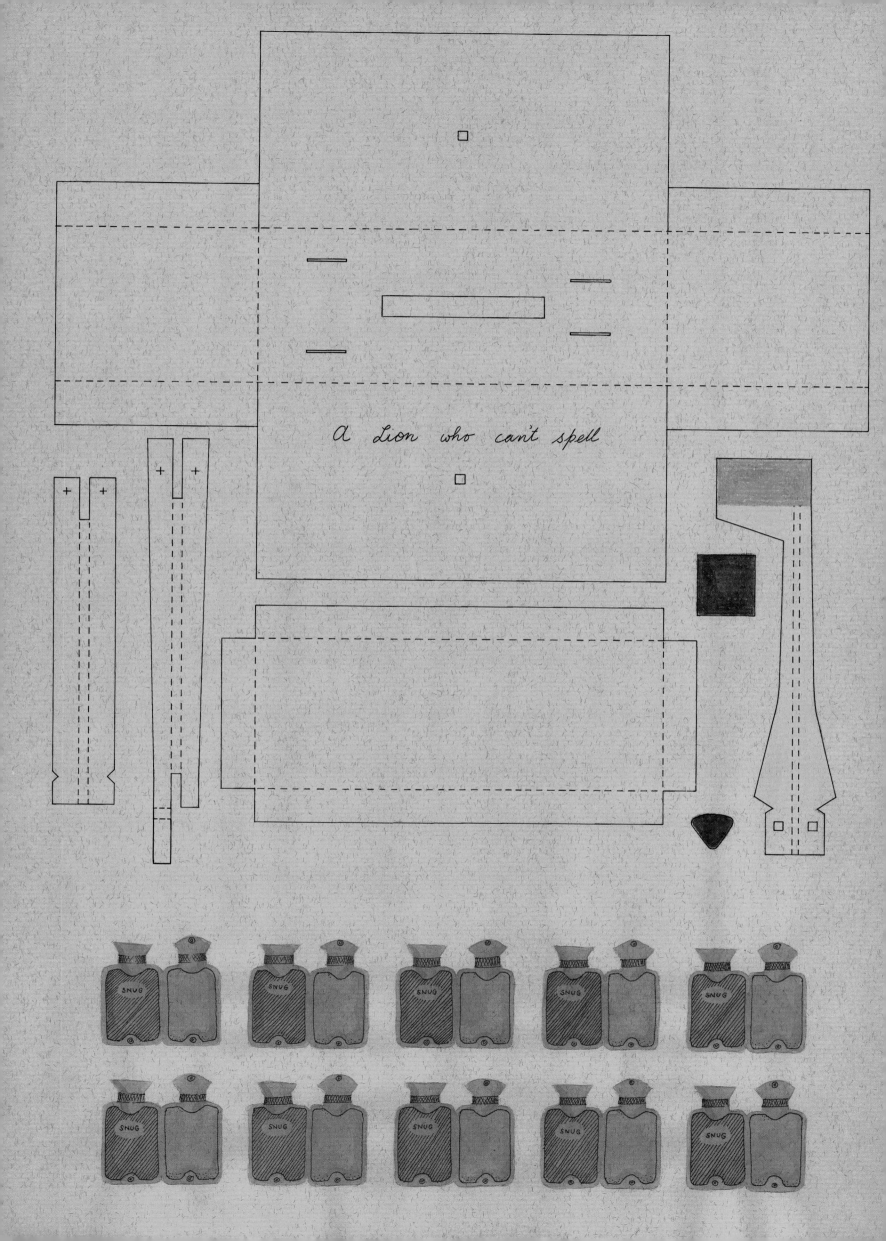

A Lion who can't spell

19

7

4 2

16

9 18

18

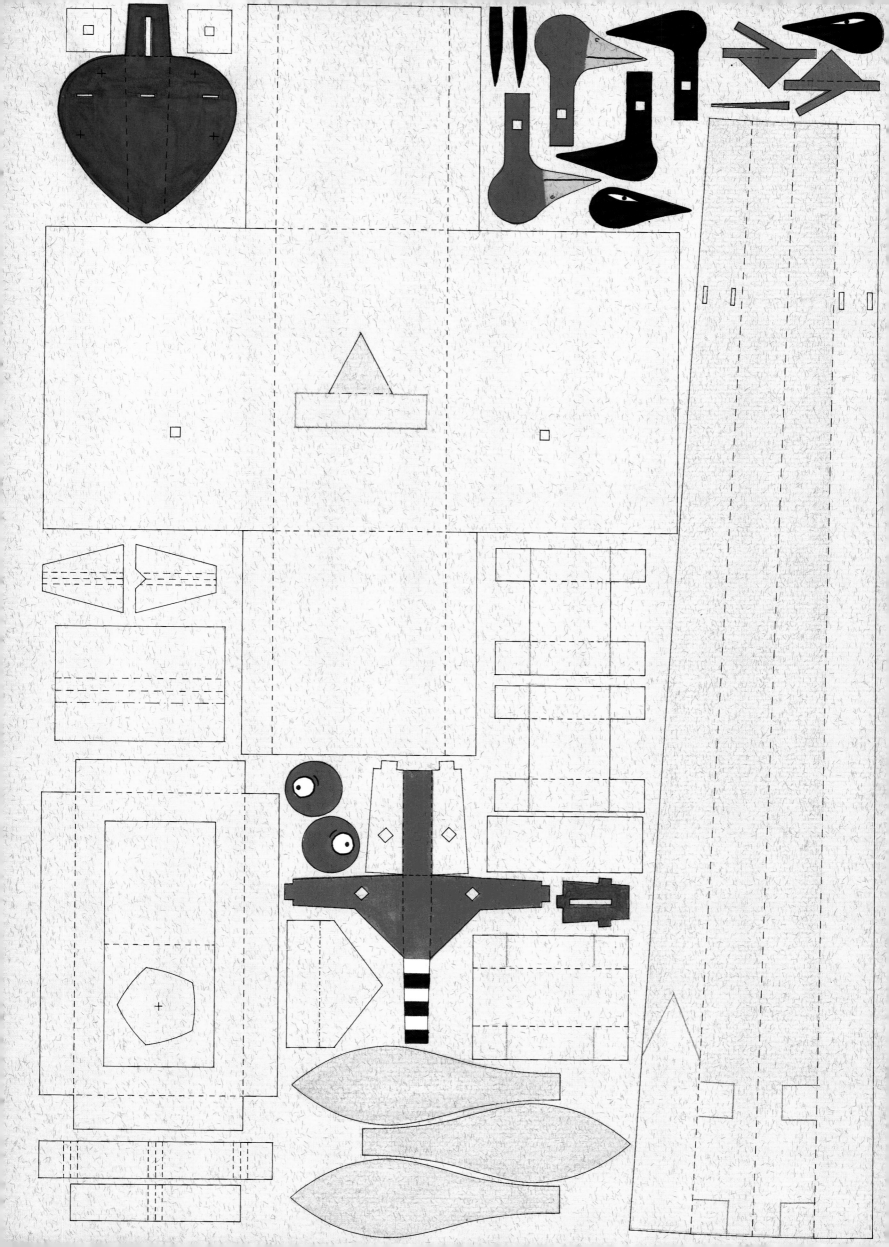

21

21

20

11 11

17

19

19 20

21

20

20

21

7 8

3

9

10

20

4

20

6

16

18

13

5 1

22 12

22

14

2 22 15

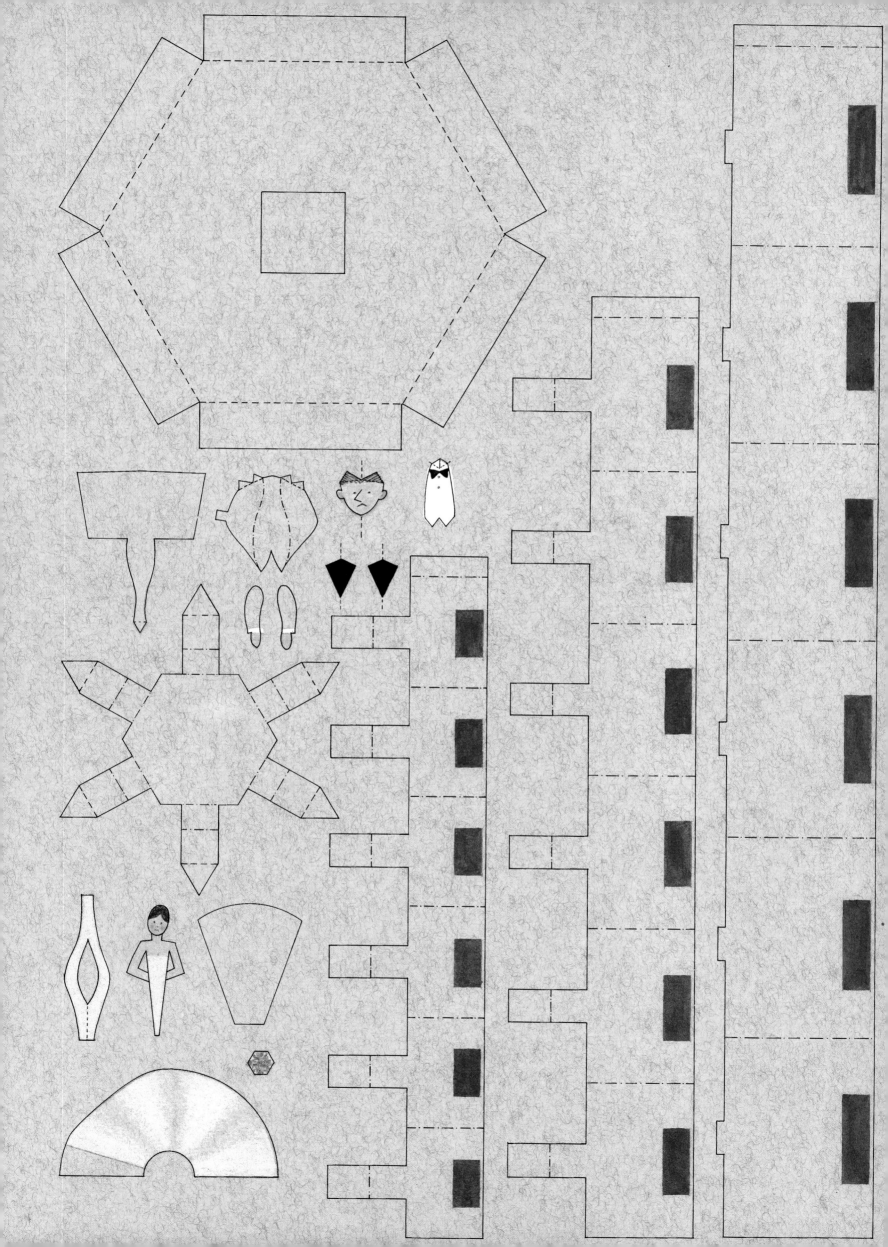

10

7 11

 22
 20 19

 4 21 21 18

 23

 1

 28 26

 25

 27

 24

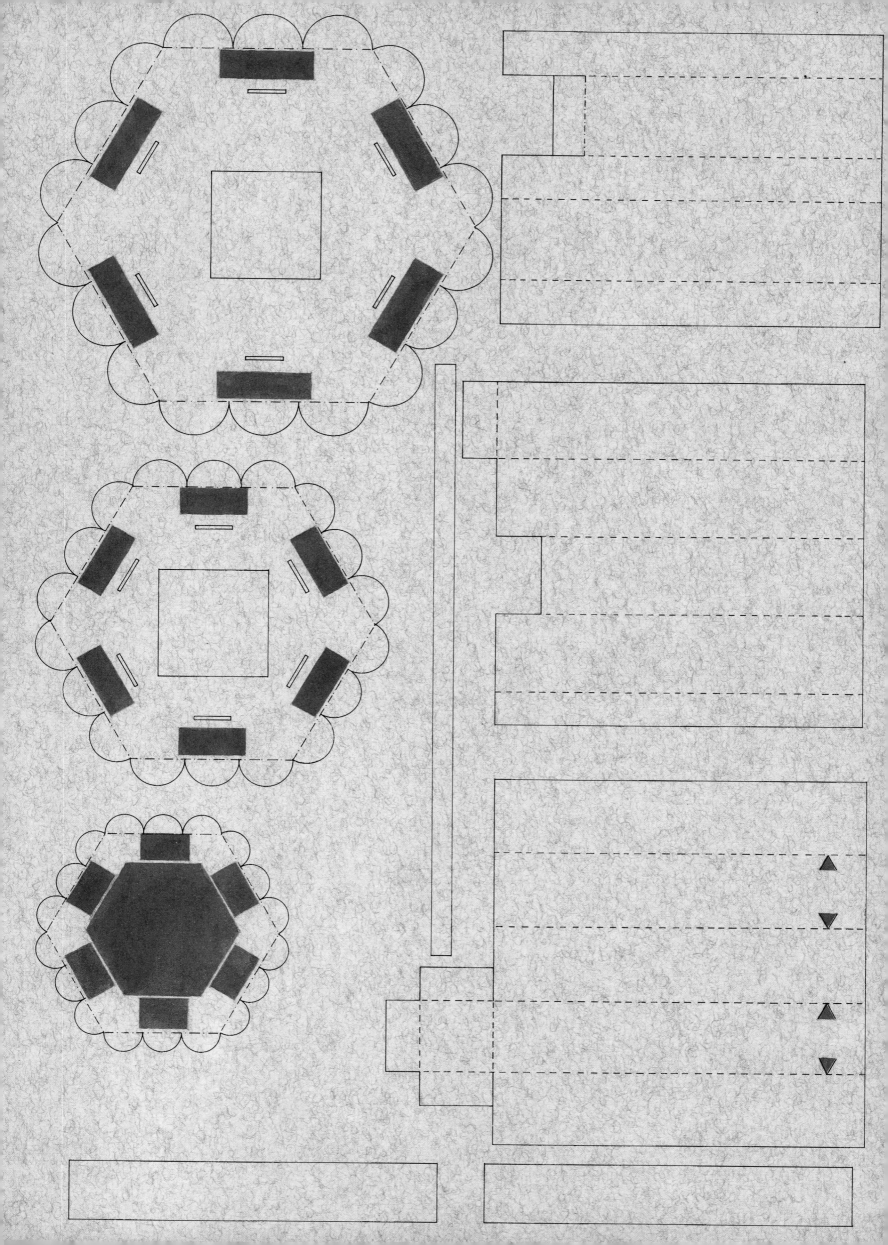

15

8

16

5

14

2

13

17 17

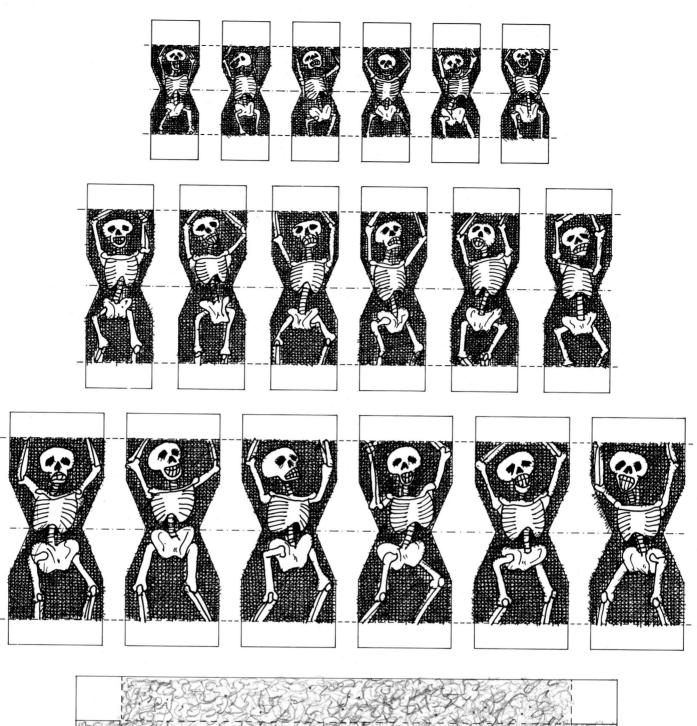

3 3 3 3 3 3

6 6 6 6 6 6

9 9 9 9 9 9

12

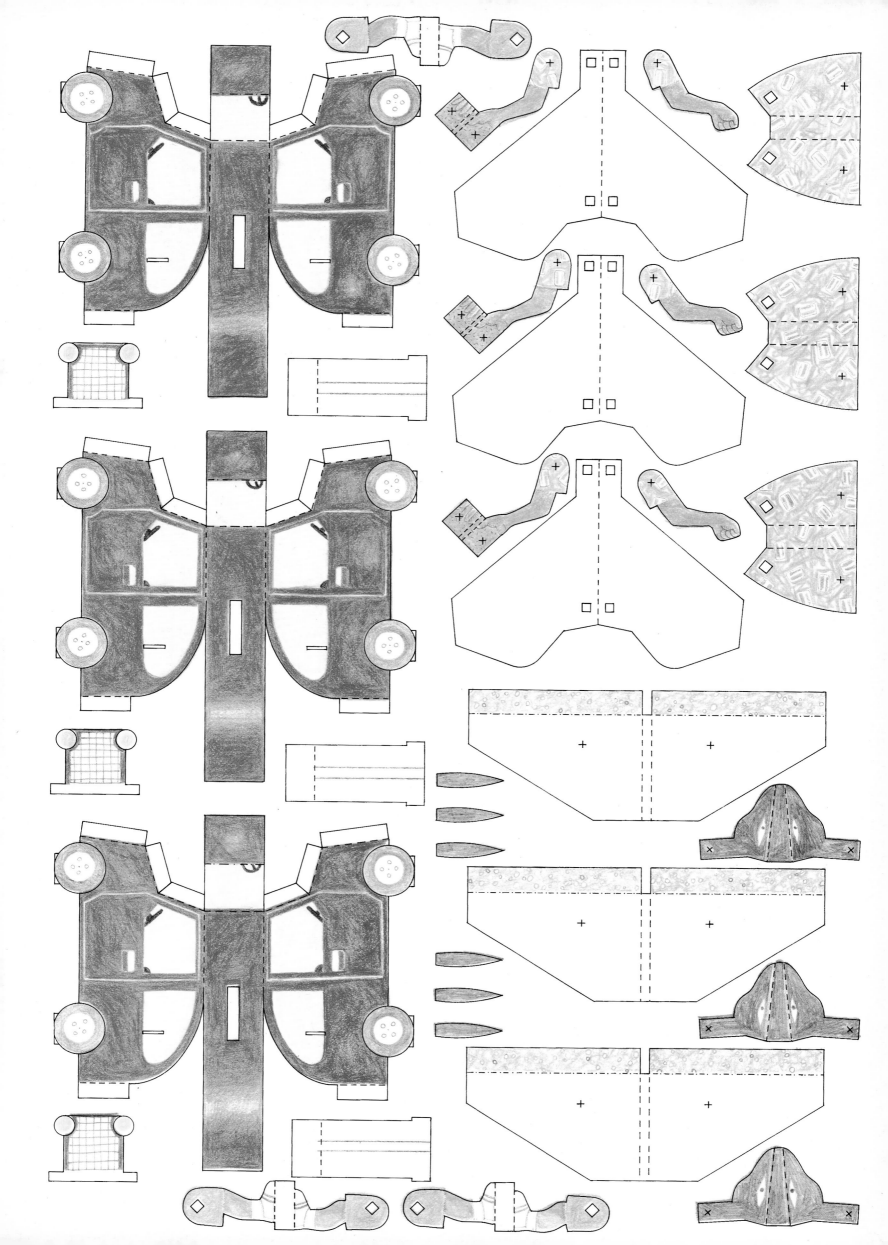

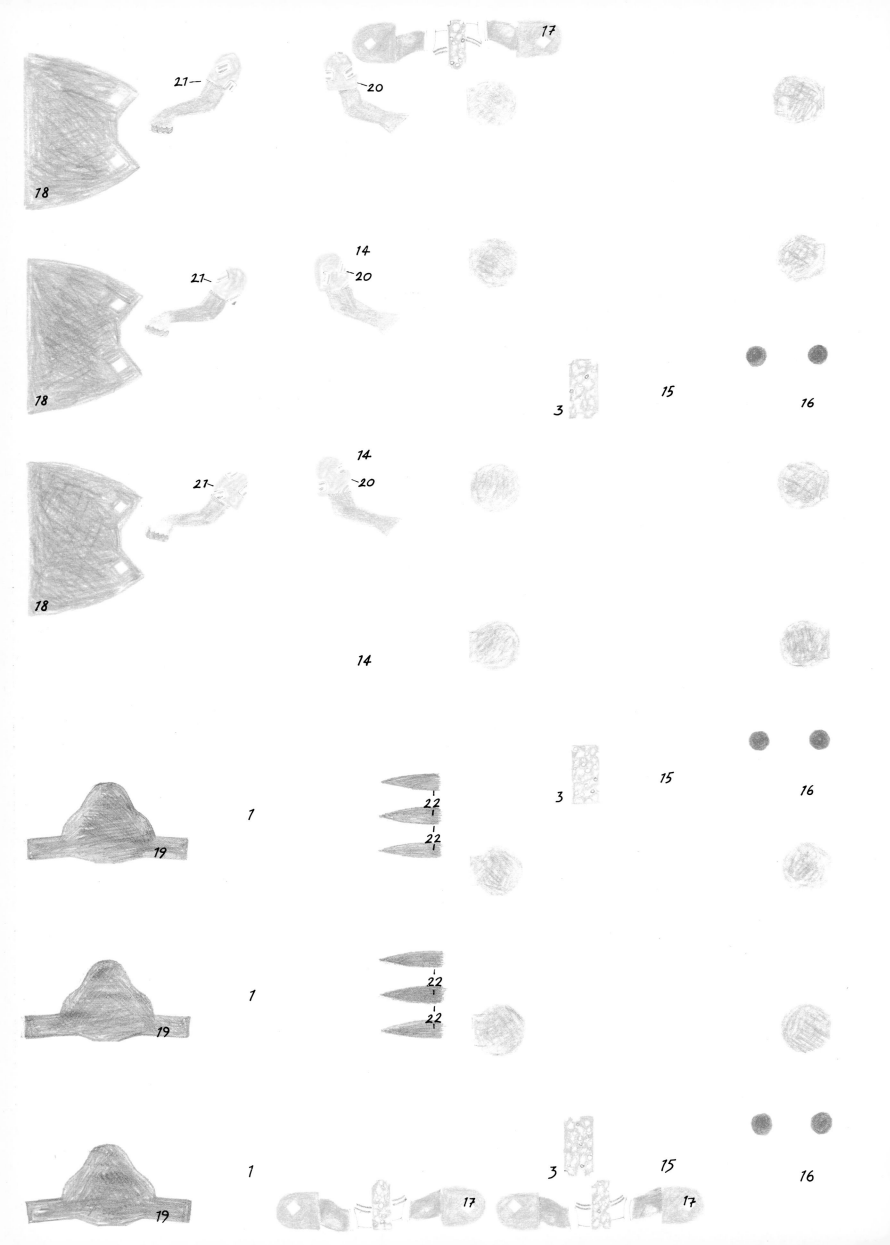

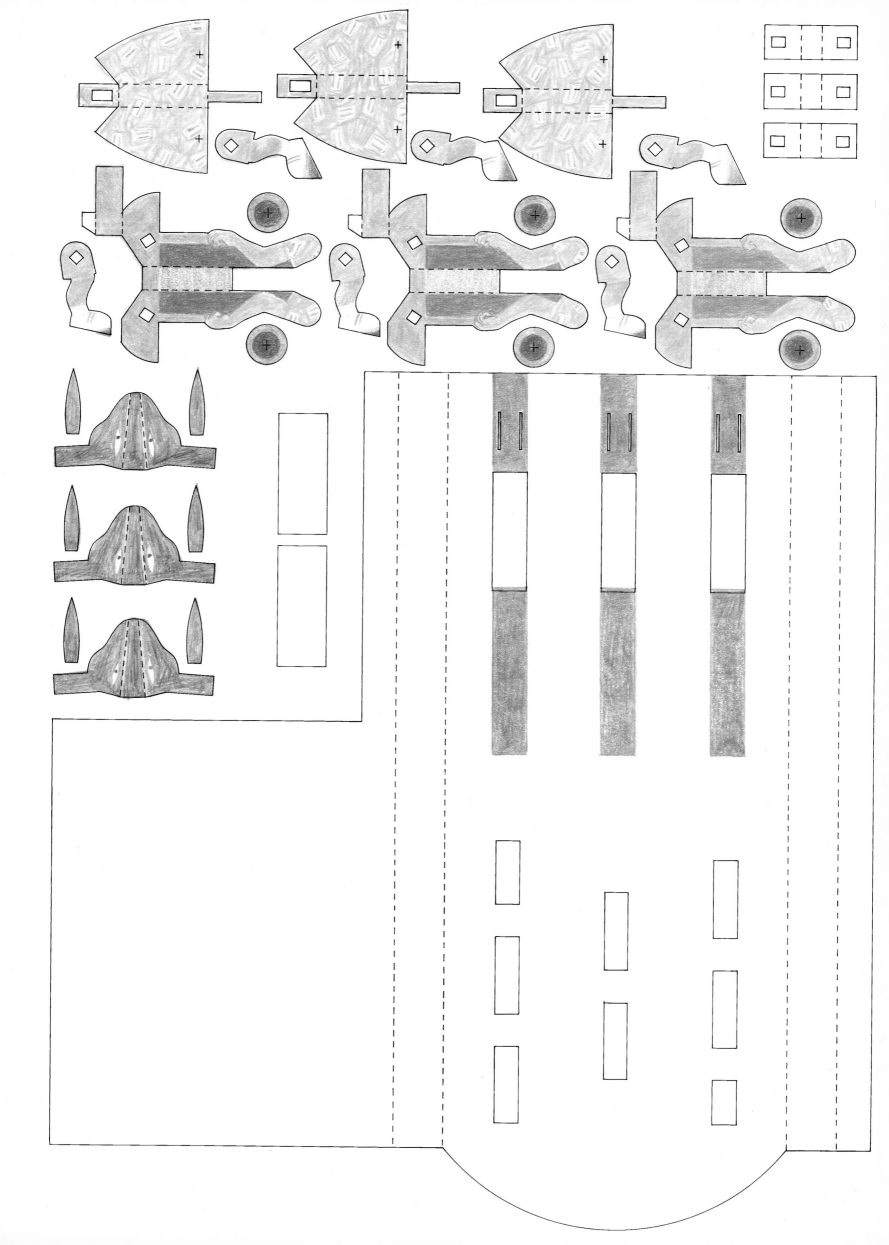

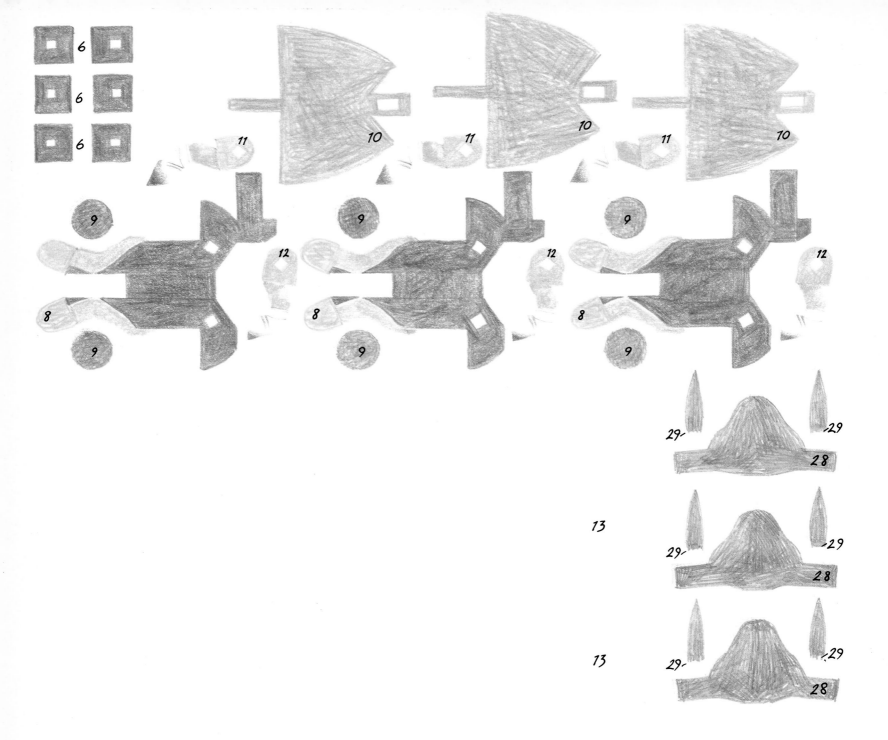

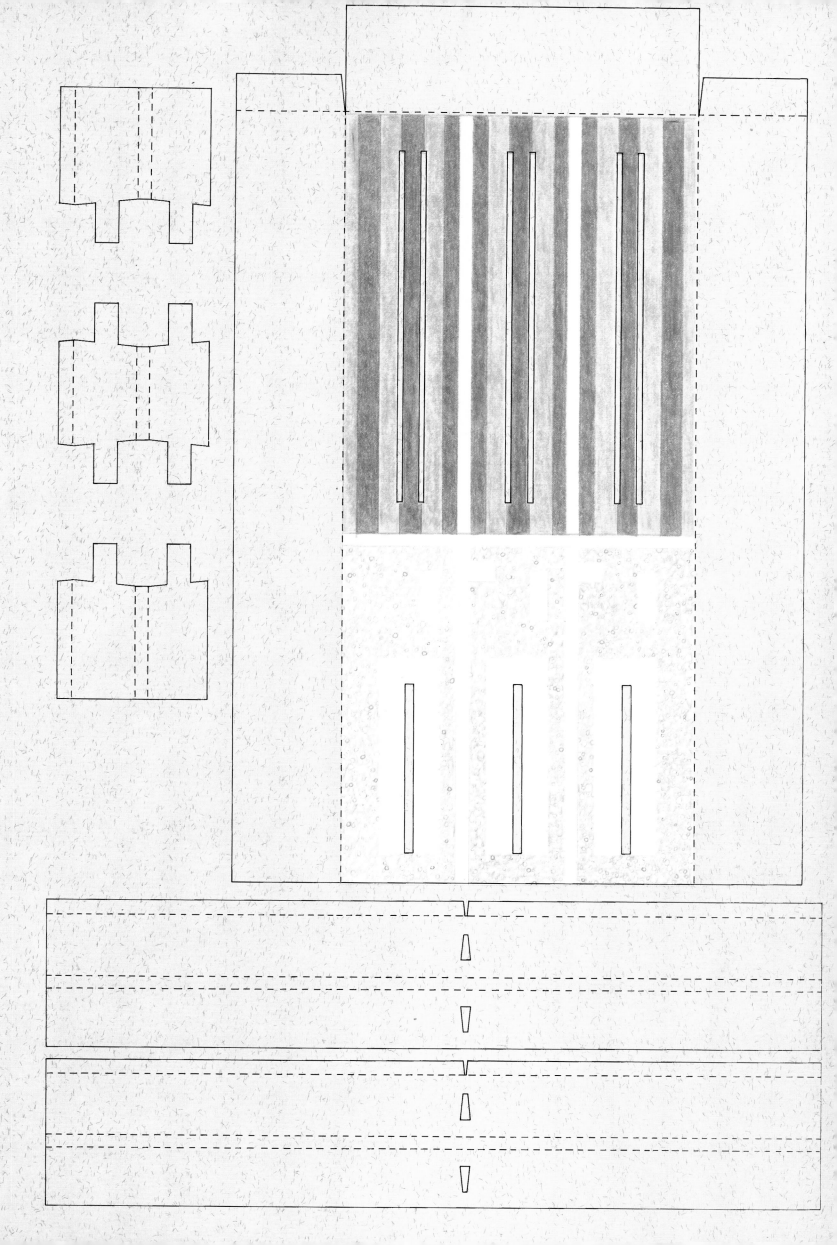

25

26

27

2

23

24

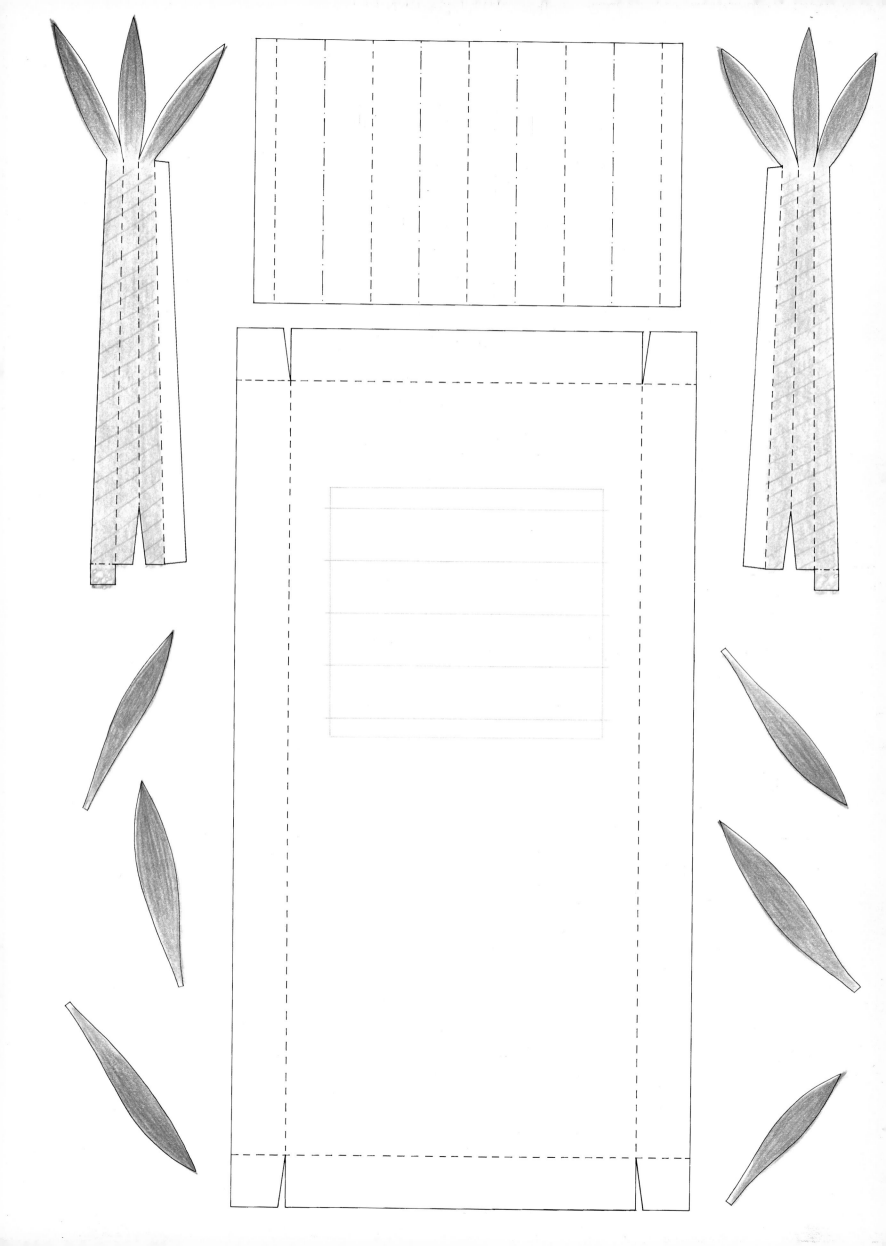

4

30 30

5

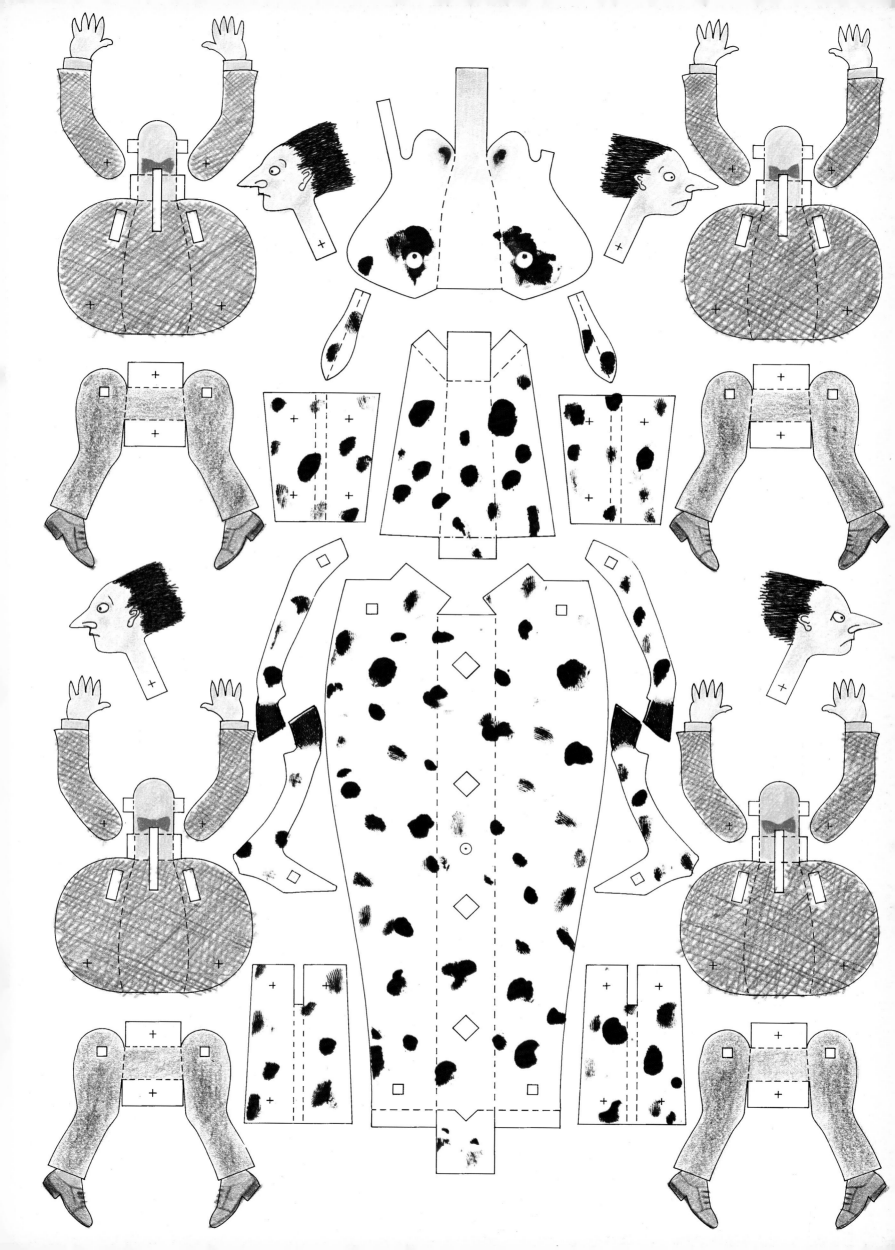

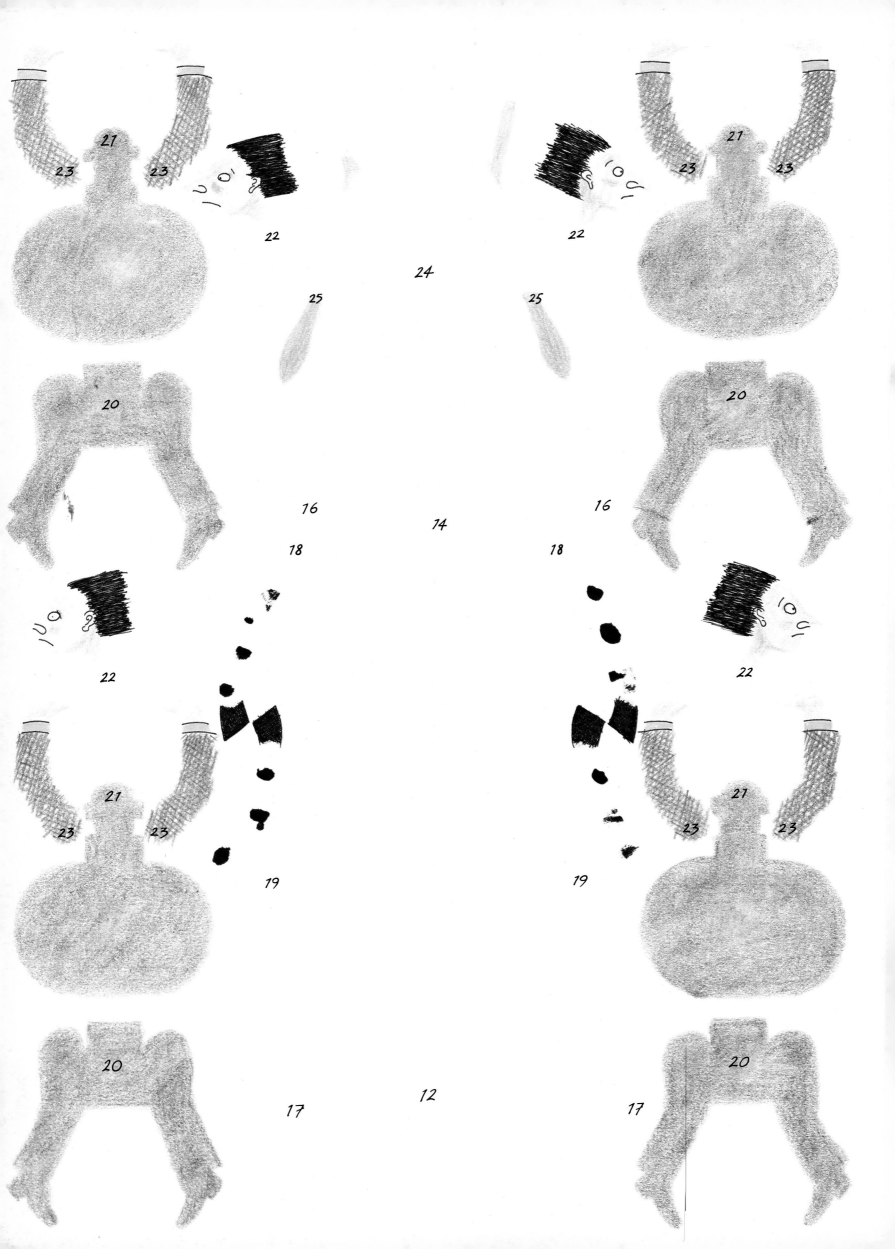

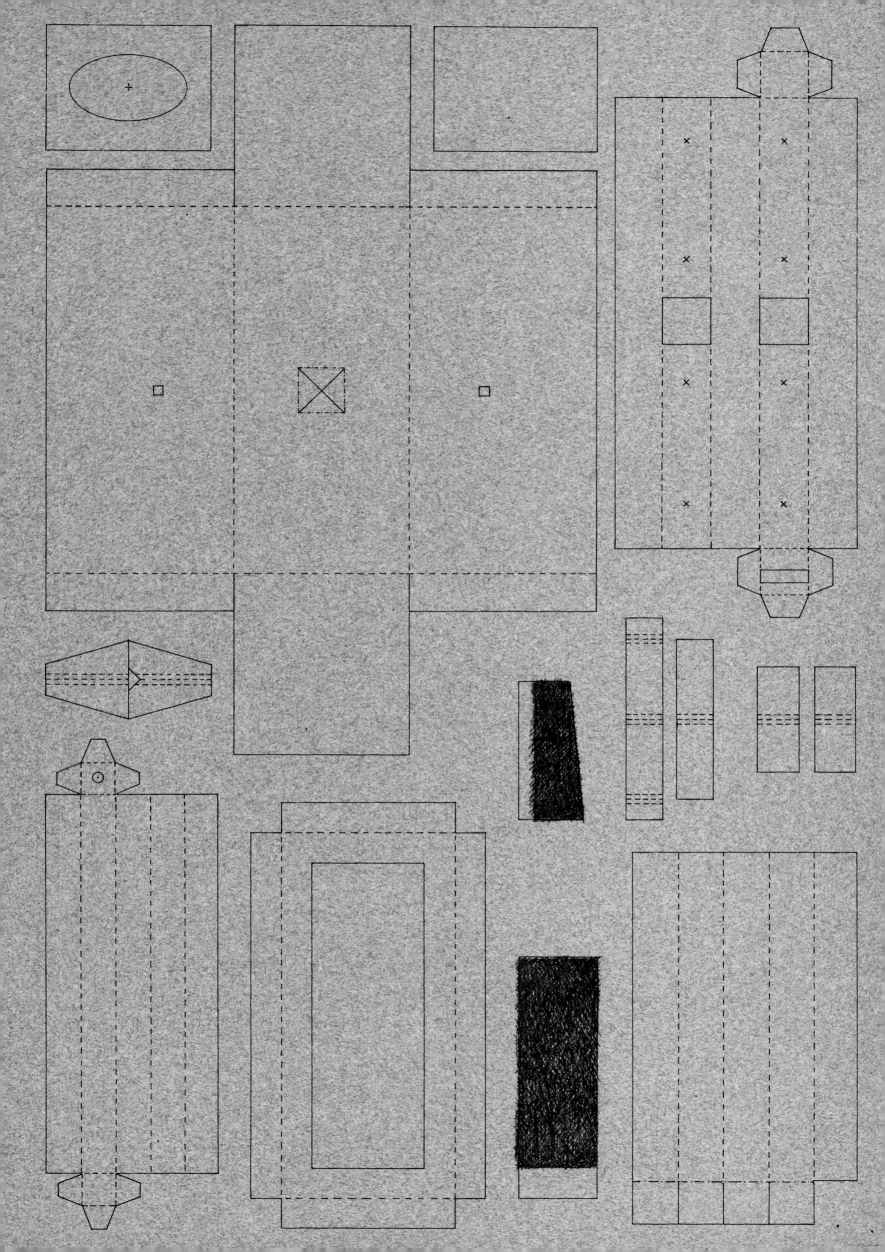

2 1

10

 3 4

 6

13 13

 8 7

 15

13

 26

 5 9 11

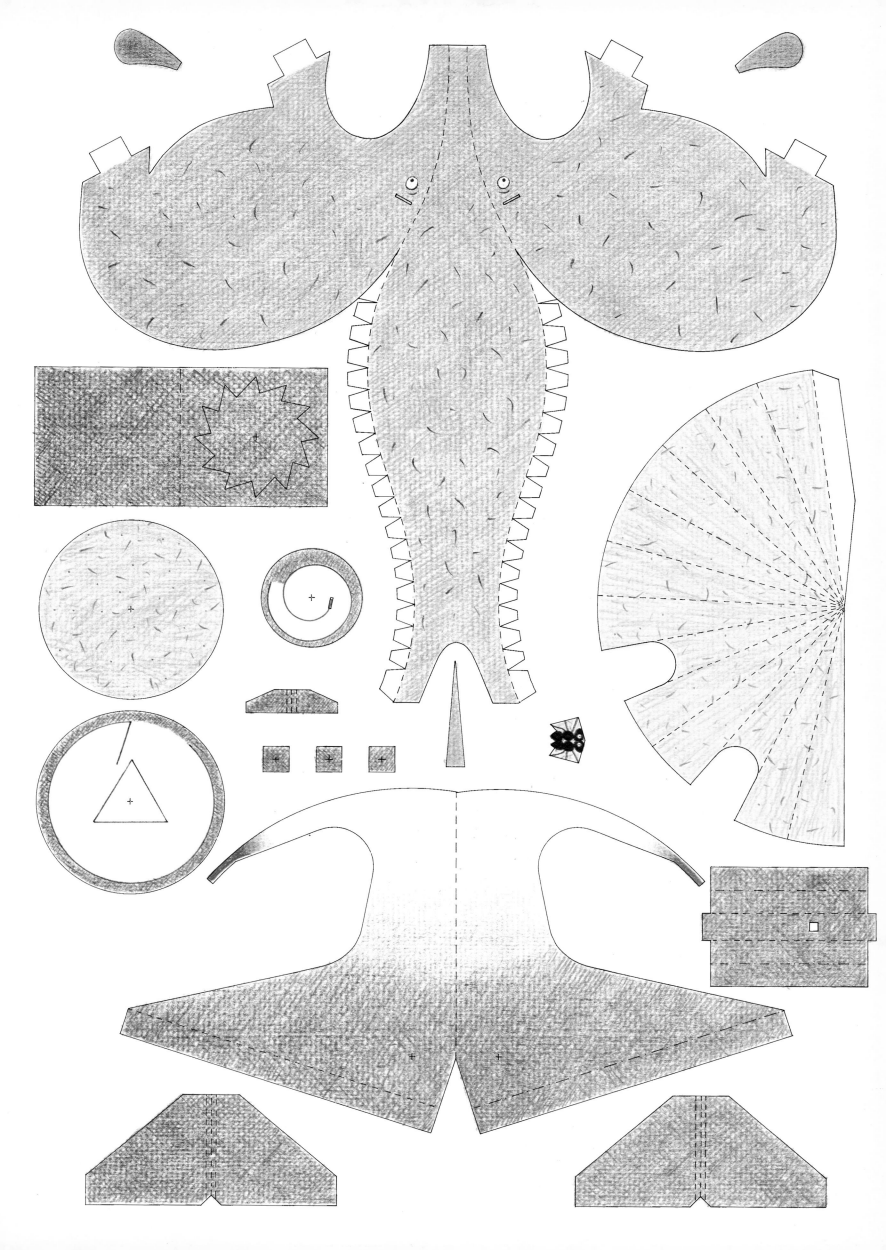

22 22

 1

 3

 27 20

 4

 25 23 5 19 19

24 7

 15

 9

 22

 10 10

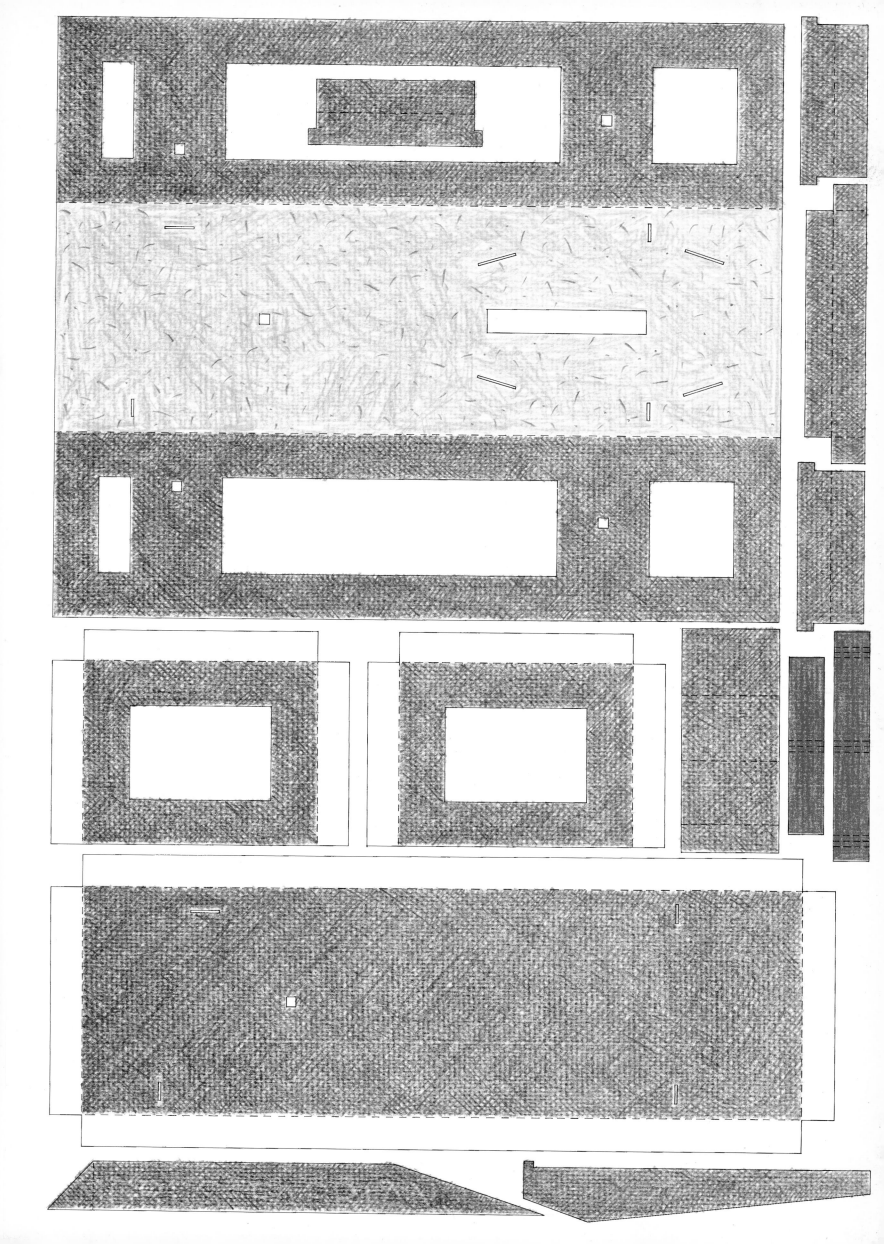

14

14

13

14 11

18 8

17 12 12

16

14

2 6

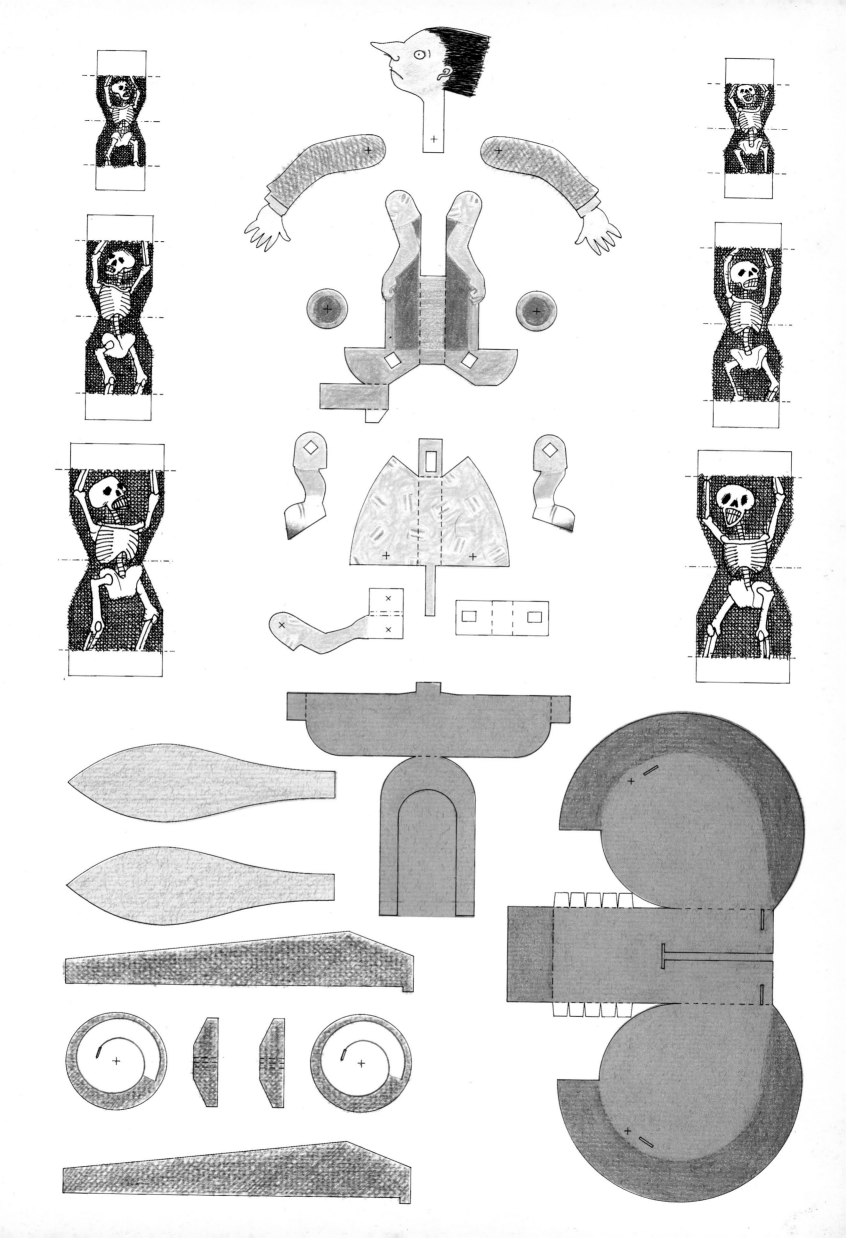